SECRET CIRENCESTER

David Elder

AMBERLEY

For David, Liz, Rosie and Lindsay

First published 2022

Amberley Publishing
The Hill, Stroud
Gloucestershire, GL5 4EP

www.amberley-books.com

Copyright © David Elder, 2022

The right of David Elder to be identified as the
Author of this work has been asserted in accordance
with the Copyrights, Designs and Patents Act 1988.

ISBN 978 1 3981 0524 9 (print)
ISBN 978 1 3981 0525 6 (ebook)

British Library Cataloguing in Publication Data.
A catalogue record for this book is available from the
British Library.

Typesetting by SJmagic DESIGN SERVICES, India.
Printed in Great Britain.

Contents

Introduction

One could talk about many different types of 'secret'. Perhaps Cirencester is famous mainly for the archaeological secrets from its past which continue to be dug up to this day, revealing astonishing insights into how it developed since Roman times, and even before. Yet, as Donald Rumsfeld might say, there is also a category of 'unknown knowns', which relate to the facts and truths we already understand and have probably documented somewhere but that we fail to fully appreciate because they lie hidden, neglected or fragmented across disparate sources. The purpose of this book is to 'dig up' these lost, forgotten or neglected facts and true stories and unveil interesting new dimensions to the history of this remarkable town.

After providing an overview of Cirencester's history, from Neolithic times to the present day, I focus attention on some of the town's lesser-known places and people. Why history remembers certain individuals and overlooks others is complex, and varies according to the vagaries of changing times and culture. I give particular emphasis to personalities such as Elizabeth Brown, the town's forgotten astronomer. Bizarrely, her voice has, until now, remained unheard in any books about Cirencester, yet, her personal struggle to find recognition for her intellect and ability as an elderly spinster in a male-dominated world speaks volumes.

There are many other interesting people and events, which have largely remained forgotten or overlooked, that I have sought to bring to life through the theme-based chapters. That Madame Tussaud brought her travelling exhibition of waxworks to the King's Head Inn on two occasions will surprise some; the fact that twenty-two Cirencester cricketers acquitted themselves well on five separate occasions against the All England XI team may impress others; and the story of the Cirencester Quaker prison inmate, who was entrusted to be left in charge of Gloucester Gaol during the gaoler's absence, seems inspired by fiction but, nonetheless, is still a true story.

While constraints of space have necessitated only brief coverage of certain important subjects, particularly in the case of transport and trade, I have still endeavoured to approach these aspects from unusual angles. The need for the railway operators to make adjustments to their timetables to make allowances for the differences pertaining to 'Cirencester time' is one case in point. Another is the emphasis given to the merchants' marks in the parish church which provide such a valuable treasure trove of information about the town's medieval trade.

As the country's second-most important city in Roman times, it is perhaps inevitable that today, even as a relatively small town, Cirencester still manages to push well above its weight and produce some remarkable firsts, whether it is the largest yew hedge in the world, the country's oldest established polo club, or the privilege of being able to swim in one of the UK's oldest outdoor pools still in use. Moreover, a place which contains such a concentrated assortment of interesting and unique heritage also reveals a wealth of fascinating curiosities, from the cult of the Deae Matres to the mystery surrounding the stone figures of buffoon, fawn and weasel that look down at passers-by near the Town Hall, and the punk rocker gargoyle who, hand over mouth, speaks no evil. I hope I have succeeded in creating more 'known knowns' about this beautiful town.

1. Before Corinium and After

While most books on Cirencester describe its development as starting from Roman times, signs of the area's earliest human activity date from at least the Neolithic period. Recent archaeological excavations carried out in the Cherry Tree Lane area during the construction of the A417/419, for example, show evidence of activity by hunter-gatherer groups dating to *c.* 7000 BC, while, in 1999, field research at The Beeches (now Pheasant Way and North Home Way) revealed evidence of occupation during the Middle Bronze-Age and Early Iron-Age periods. Other studies, at Cirencester Park Polo Club, the rugby ground, Leaholme, and at Kingshill North, also provided evidence of pottery from the Beaker Period (2300–1600 BC).

More significantly, several large burial mounds exist within the town or along its edges. One that is almost certainly a Neolithic long barrow, typical of the Cotswolds, is located at the Querns, close to the Roman Amphitheatre, near the entrance to the hospital. Measuring 55 metres long by 15 metres wide and 1 metre high, the barrow contained several heavily fragmented skeletons when it was excavated at the end of the nineteenth century.

The Querns barrow, viewed from the amphitheatre.

The southern barrow of Tar Barrows, viewed from Burford Road side.

Given its proximity to the amphitheatre, it seems likely that the Romans considered this barrow and another, known today as Grismond's Tower (measuring 30 metres across and 4 metres high), located 350 metres north (approximately 150 metres from Cirencester Park Mansion) as sacred sites, since neither were desecrated.

Another set of twin burial mounds, which appear to have been viewed as sacred by the Romans, is located on Tar Barrows Hill at the north-east side of the town. Acknowledged as possibly dating from the second millennium BC, these barrows, which may have been incorporated into a later prehistoric or Roman temple, possibly influenced the routes of the Fosse Way and Ermin Street, and even the location of the Roman town of Corinium, since, it is thought, the Romans deliberately diverted the roads around the barrows.

Corinium

Established c. AD 75 the town, initially known as *Corinium Dobunnorum*, served as a major centre – second only in importance to London – for the administration of the conquered Dobunni tribe, who lived in the southern Cotswolds. Evidence of the Roman settlement is fully described and illustrated in the town's world-famous Corinium museum. It is also tangibly revealed in surviving sections of the town wall, and the amphitheatre, located on the southern outskirts. Apart from these high-profile sites there are still many unusual objects and unexpected features dotted around the town which provide further proof of

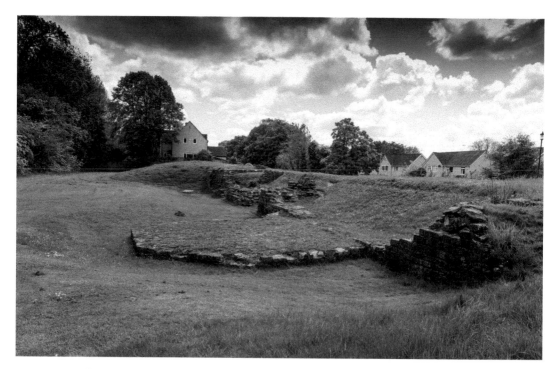

Section of the surviving Roman wall in the Abbey Grounds.

The Roman stone coffin at Cirencester Park Mansion.

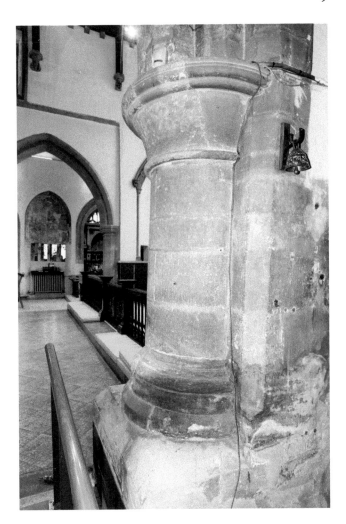

A Roman pillar, now incorporated into the parish church.

the town's enduring Roman legacy. Take the stone coffin lying in the grounds (not publicly accessible) of Cirencester Park Mansion, for example, which, to the unknowing eye, may appear centuries, not millennia, old; or the occasional sections of Roman pillar which, today, can be discerned incorporated into the interior of the parish church.

DID YOU KNOW?

The name Corinium possibly derives from the Celtic word *corin* (meaning 'corn'), and this may also be the origin of the word for Churn, the town's river. Further evidence suggests that the Romans borrowed the name from the local Dubonnii tribe, who were members of the Cornovii people. This theory is supported in Ptolemy's reference to Korinion in his *Geographica* (AD 150).

Anglo-Saxon and Early Medieval Periods (*c.* 410–1066)

By the end of the fourth century the days of Roman authority had become numbered. Thereafter, there is some conjecture that the town was possibly visited by a devastating plague. What is certain, nevertheless, is that following the Battle of Dyrham in AD 577, Cirencester (which later derived from its Saxon name *Coryn Ceastre*), together with Gloucester and Bath, was one of three cities seized by the Saxons. Fifty years later, in AD 628, the *Anglo-Saxon Chronicle* records, the Battle of Cirencester was fought between the armies of Mercia, under King Penda, and the Gewisse (predecessors of the West Saxons), under Kings Cynegils and Cwichelm, leading the town to fall under Mercian domination.

At this time, the town was largely centred around the present-day Cecily Hill area, north-west of the abandoned Roman city. By the end of the ninth century Cirencester was invaded again, this time by the Danes, the Danish influence possibly evident in Inchthorpe (medieval Instrop), an old name for Cecily Hill, the 'thorpe' suffix (meaning 'village') thought to be of Scandinavian or Saxon origin.

Medieval and Tudor Periods (1066–1603)

By the time of Domesday, an Anglo-Saxon church, St Mary's, had been built and the royal manor of Cirencester granted to the Earl of Hereford. From around the 1150s construction of the parish church began, some medieval tomb-covers still visible at the base of one pillar. An Augustinian abbey, also dedicated to St Mary, and demarcated in the Abbey

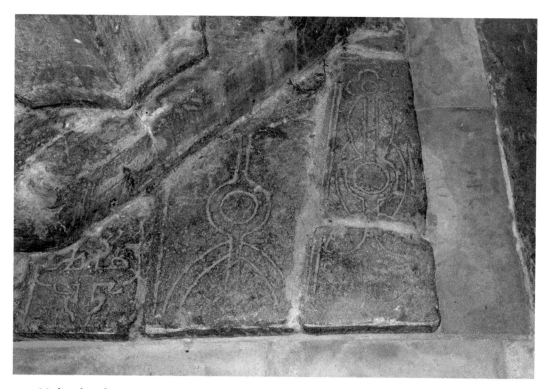

Medieval tomb covers in the parish church.

Grounds, was founded by Henry I in 1117. It now started to dominate town life during the next four centuries. Nevertheless, one exception occurred during the civil war between King Stephen and Empress Matilda when the wooden structure of Cirencester Castle – thought to have been sited behind the present-day Cirencester Mansion's yew hedge in Park Street – was burned down by Stephen in 1142.

During the Middle Ages much of the town's wealth derived from sheep-rearing, the woollen trade, weaving, and production of reputedly the finest cloth in Europe. Such prosperity enabled the merchants to rebuild the parish church's nave in 1515–30, leading St John's to become known as 'the Cathedral of the Cotswolds'. One of the most remarkable of the town's wool merchants was Reginald Spycer (d. 1442). Commemorated in a fifteenth-century brass in the Trinity Chapel of the parish church, together with his four wives – Margaret, Juliana, Margaret and Joan – Spycer, as a Yorkist, played a prominent role in the Epiphany Rising of 1399–1400, supporting Henry Bolingbroke (later King Henry IV) in deposing Richard II. The historical event was referenced briefly in Shakespeare's play *Richard II* (*c.* 1595) when Henry proclaims:

Kind uncle York, the latest news we hear / Is that the rebels have consumed with fire / Our town of Cicester in Gloucestershire. But whether they be taken or slain we hear not.

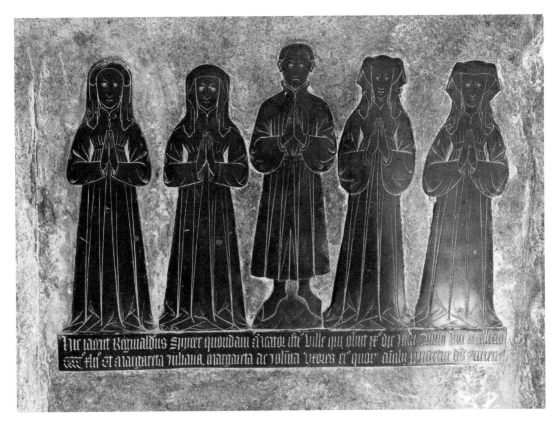

Reginald Spycer, reputed as a troublemaker and for having four wives.

Among the ringleaders of the conspiracy against King Henry were John Montagu, 3rd Earl of Salisbury, and Thomas Holland, 3rd Earl of Kent. They came to Cirencester in January 1400 in an attempt to raise more support, but were captured by the townsmen who, after blockading them in their lodgings at the Ram Inn, threw them into the Abbot's gaol. After the earl's supporters burned down houses in Gloucester Street in retaliation, the townspeople became so enraged that they executed the earls in the Market Place the following day. While their bodies were buried at Cirencester, their heads were sent to the king and displayed on London Bridge. Subsequently, the king rewarded the town for its loyalty with annual grants of deer and wine. Nevertheless, some disquiet remained in the town, largely fuelled by the Abbots' past usurpations, which led to the withholding of all manorial services. Although the town was subsequently successful in petitioning the king for the more generous reward of having its own guild merchant so that it could control its trade, in 1402 the king sought to arrest a number of Cirencester citizens who were considered to be troublemakers. Among these was Reginald Spycer. Nevertheless, they were soon pardoned, and to further reward the town's loyalty the king donated treasure, previously seized from the rebellious earls, which was used to build the church tower.

Various charities were also founded, principally for the poor, including the grammar school (established in 1458), the Hospital of St John in Spitalgate, and the

Hospital of St John.

oldest present-day secular building, St Thomas's Hospital in Thomas Street, originally established in 1483 for four poor weavers. However, nothing could be done to save the abbey, which was demolished following the Dissolution (1539). Despite this, there are still many remnants of this hugely significant building, notably the Norman Arch, built in 1180, and ruined sections of the precinct wall. Much less visible, though, yet identifiable in places, is some of the abbey's recycled stonework, now incorporated into the parish church and nearby houses.

One of the memorable stories emanating from the period is captured in a painting by John Beecham (1813–82). Famed for painting romantic historical scenes, Beecham drew inspiration from *Foxe's Book of Martyrs* (1563) which records the visit by John Hooper, Bishop of Gloucester. Viewed as a radical Protestant reformer, Hooper was being transported from London's Fleet Prison to Gloucester, to be burned at the stake for heresy the next day. Staying overnight in Cirencester in February 1555 it is said:

[he] dined at a woman's house who had always hated the truth, and spoken all evil she could of Master Hooper. This woman, perceiving the cause of his coming, showed him all the friendship she could, and lamented his case with tears ...

Norman Arch, built in the 1100s as the abbey gatehouse.

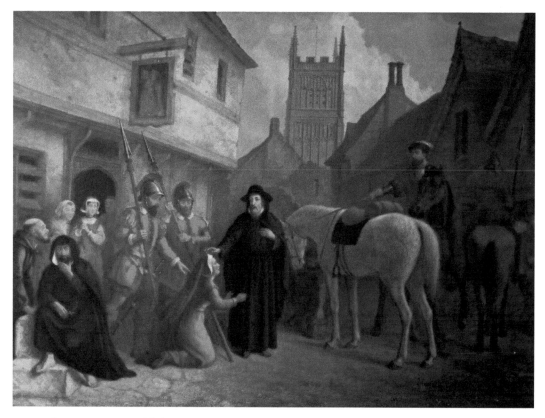

Bishop Hooper in Cricklade Street, 1555, by John Beecham.

While the event was later honoured through the naming of Hooper's Court (off West Way), the name of the neighbouring St Blaize (*sic*) Court is sometimes mistakenly associated with Hooper's martyrdom: in reality, it refers to the St Blaise Inn (visible in the left of Beecham's picture), which once stood in Cricklade Street, probably named after the patron saint of wool-combers.

Less romantic images of the period may be imagined as a result of the scourge of the Black Death (bubonic plague) pandemic which swept across Britain in 1348, continuing to haunt the country for the next three centuries. In Cirencester, the parish records reveal how the town was particularly badly devastated in 1578 when 500 deaths occurred, three times as many as in the previous year. Some of the personal family tragedies may be pieced together from the paper trail of surviving documents. Robard Benet (Robert Bennett), for example, a Cirencester shoemaker, chose to write his will, 'now in this tyme of godes visytatyon of the pestelence', on the same day, 10 July 1578, that his wife Elinor was buried. While no doubt prompted to arrange care for his two sons and one daughter, sadly, one of his sons was buried fifteen days later, and Robard himself the following day. His daughter also succumbed to the plague shortly afterwards, leaving the remaining son to be looked after by his brother-in-law.

DID YOU KNOW?

Several medieval chroniclers tell the story of Cirencester being burned to the ground using birds as an incendiary weapon. Usually associated with the Danish king Gormund, it describes how, after being unable to conquer the town, he uses the stratagem of ensnaring sparrows which are known to nest in the town's thatched roofs. Then, by attaching firebrands to the sparrows, the birds return to their nests, causing destruction and distraction from defence against the besiegers. The legend is also recounted in the poem 'The Birds of Cirencester' (1898) by the American author Bret Harte.

Stuart and Georgian Periods (1603–1837)

Another event which inspired Beecham's brush was the attack on Lord Chandos' coach, which took place in August 1642 at the start of the Civil War. As Deputy Lieutenant for Gloucestershire, Lord Chandos came to Cirencester to raise troops for the king. Nevertheless, he met considerable hostility. Although he evaded the angry mob, escaping secretly soon after his arrival, the next day his coach was torn apart in the Market Place. Soon, Cirencester became a divided town, the Royalists, on the one hand, being supported by the gentry and clergy, and the Parliamentarians, on the other, by the townsfolk.

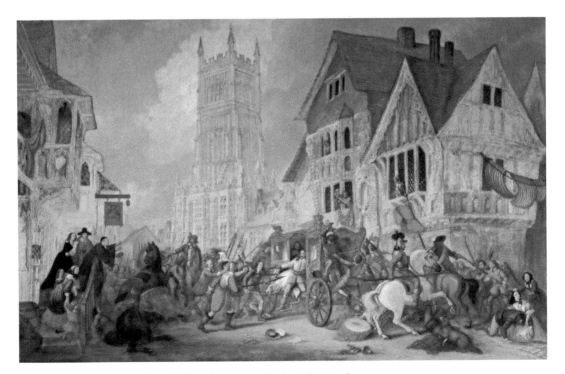

The Attack on Lord Chandos' coach, August 1642, by John Beecham.

After Prince Rupert, one of Charles I's most successful commanders, captured Cirencester on 2 February 1643, over 300 people were killed, including a local clothier, Hodgkinson Paine, who died with the Parliamentary colours in his hand, his pun-filled epitaph in the parish church recording 'Hee looseing quiet by warre yet gained ease, by it PAINE's life began & pains did cease'. Hundreds of prisoners were also captured and held in the parish church overnight, their friends and relatives breaking some of the windows to pass food and drink to them. After being marched to Oxford, the following day, the prisoners were allowed to return home once they swore allegiance to the Crown. Such was the town's adherence to the Royalists thereafter that the parish bells are still rung on 29 May (Oak Apple Day), which, since 1660, has celebrated the Restoration.

Two large estates, originally established during the sixteenth century following the dissolution of the abbey, now came to assume particular significance. Part of the original Oakley Manor estate, which was initially given to Elizabeth I's treasurer, was sold to the queen's physician Richard Master in 1564. Located on the site of the abbey, it boasted a fine Jacobean house, rebuilt in 1774–76. Known as Abbey House, it was demolished in 1964, from when the grounds were gifted to the town. The second estate was bought by Sir Benjamin Bathurst (1638–1704) in 1695 for his eldest son, Allen. As Deputy Governor of the Leeward Islands and through holding similar roles, along with shares, in the Royal African Company, Benjamin had gained considerable wealth through slavery, though, later, his great-grandson, Henry, the 3rd Earl Bathurst (1762–1834) became known for his anti-slavery stance. While this sometimes proved challenging during Henry's office as Secretary of State for War and the Colonies from 1812 to 1827, his contribution towards

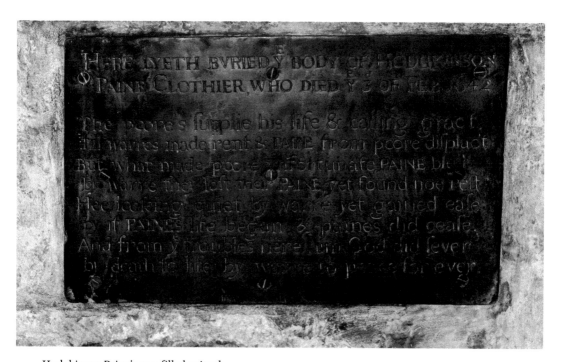

Hodgkinson Paine's pun-filled epitaph.

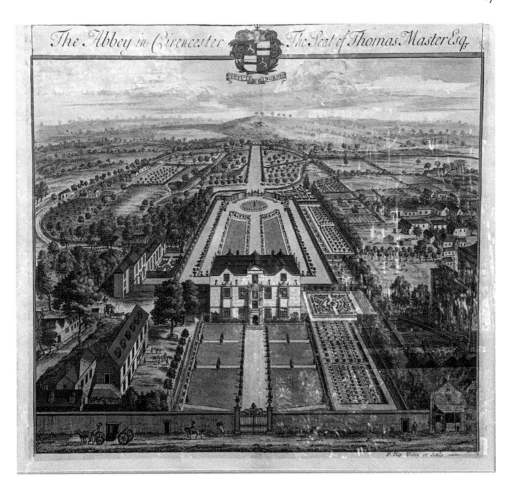

The Abbey in Cirencester — The Seat of Thomas Master Esqr

Above: The Jacobean house depicted by Johannes Kip in 1712.

Right: Abbey House taken from the parish church in 1962.

The Queen Anne monument, Cirencester Park.

abolition was recognised in 1816 when Gambia's capital, now Banjul, became known as Bathurst in the earl's honour.

It was Allen, whom Queen Anne created Baron Bathurst in 1712, who became the 1st Earl Bathurst, erecting a fine monument in the queen's memory on the estate in 1741. In 1766 Cirencester became one of the places where food riots took place in response to rises in grain prices caused by a series of poor harvests and continuing exports. One of the rioters, Thomas Sawyer, was sentenced to seven years' transportation at Gloucester Assizes 'for committing outrages at Cirencester, and, with others, stealing a large quantity of cheese from Mr. Croome of that place'.

By 1808 the town contained 885 houses and 4,130 inhabitants – a far cry from when 15,000 people intermingled in Roman Corinium. Now, as the town's population started to gradually increase, so too did its levels of deprivation. This prompted the two largest landowners, the Earl Bathurst and Jane Master, to galvanise support for establishing town commissioners in 1825 to improve living conditions. Around this time, cultural advances, such as the opening of a public subscription library in 1835, were made along with infrastructure improvements, including the introduction of a gas supply from 1833. A workhouse (now occupied by the Cotswold District Council offices) for 300 inmates was built in 1836 on the site of a former parish poor house at Watermoor.

One of the most remarkable stories connected with the workhouse concerned the children of George Bond, a master blacksmith who lived in Park Street. Originally

The workhouse prior to its conversion to council offices.

sent to the workhouse following the death of their mother in 1870, two years later the seven children were taken by their father to start a new life in Brazil. Tragically, within four months they were left without proper care and protection after their father died, probably from drunkenness. Subsequently admitted to a Brazilian orphanage, the children, it was claimed, would have been sold into slavery had some English immigrants not intervened. The case was even highlighted to Lord Granville, then foreign secretary, who ensured that their plight was investigated. While the eldest daughter, Clara, returned to become an inmate of the Cirencester workhouse again in July 1874, the rest of her siblings, who were initially placed under the care of respectable families, made their lives in Curitiba and the Brazilian area of Paraná, where, today, the Bond surname can still be found in local directories.

Victorian Period (1837–1901)

The town's population continued to expand, reaching just over 8,000 by the end of the nineteenth century. Among the notable development was the establishment, in 1837, of a newspaper, the *Wilts and Gloucestershire Standard*, for the town and surrounding area, and, in 1845, the founding of the Royal Agricultural College, the first college (now a university) of its kind in the English-speaking world. Nine years later, the first Corinium Museum was established. Funded by the 4th Earl Bathurst, the museum housed

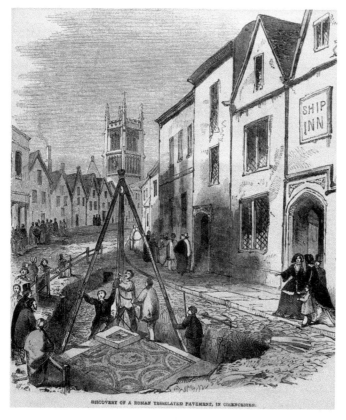

DISCOVERY OF A ROMAN TESSELATED PAVEMENT, IN CIRENCESTER.

The Roman mosaics discovered in Dyer Street in 1849.

the Roman mosaics, discovered in Dyer Street during excavation work to lay a sewer, depicting hunting dogs and the seasons. From the economic point of view, corn replaced wool as the town's principal activity. Its importance can still be appreciated through the lavishly decorated Corn Hall, constructed in 1863, which overlooks the Market Place. Apart from being used as a centre for agricultural trade, the building also served as a school of art, library, and venue for concerts, plays and talks. These varied uses are reflected in the façade's symbolic carvings, believed to be the work of Henry Frith (c. 1820–63), a Westminster-born craftsman. The sheaf of wheat with a plough and rake represents agriculture, while commerce is portrayed through a ship, anchor and globe. The world of fine arts is characterised by a palette, easel and bust, and music by a harp and trumpet.

DID YOU KNOW?

One of the world's rarest word squares was discovered in a garden in what is now Victoria Road in 1868. Roman in origin the acrostic, which reads the same forwards as backwards, is thought to contain a secret Christian code. Only two similar ones have ever been previously discovered, in Pompeii.

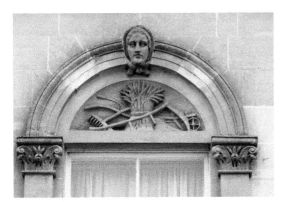
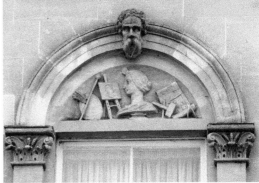
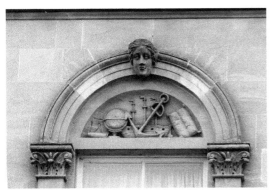
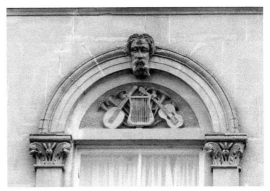

The Corn Hall's symbolic carvings which reveal its prior usage.

The Modern Era

By the beginning of the twentieth century other private benefactors made further contributions to improve the town. Among these was Daniel George Bingham, the son of a local cabinetmaker whose career included reorganising the Dutch-Rhenish railways. Sometimes dubbed as 'Cirencester's Carnegie', Bingham spent some of his large wealth, partly accrued through judicious investments, to fund and run a professional library service and, in 1908, a hall, primarily used for lectures. However, following the outbreak of the First World War the hall was quickly converted into a Red Cross Hospital. In total, it treated 1,852 patients, who arrived at short notice from the Western Front via Southampton.

Throughout the twentieth century significant commercial and housing development took place, and continues to do so at the present time. More recently, in 2020, when the coronavirus pandemic spread to Cirencester, the cycle of disease, suffering and death revisited the town once again. While the plague led to annual deaths averaging 117 during the 1570s, the weekly number of Covid 19-related deaths in the area occasionally exceeded twenty between March 2020 and September 2021. Although the town's experience of this latest pandemic may not be considered that unusual, the way in which one Park Street resident decided to commemorate the repairing of his property's perimeter stone wall (not publicly accessible) during the Covid-19 lockdown certainly was: how else could a Cirencestrian record the time when the plague returned to cross his threshold ('... limine dum pestis ...') except in beautifully carved Roman Latin that also, within its red letters, contains a chronogram?

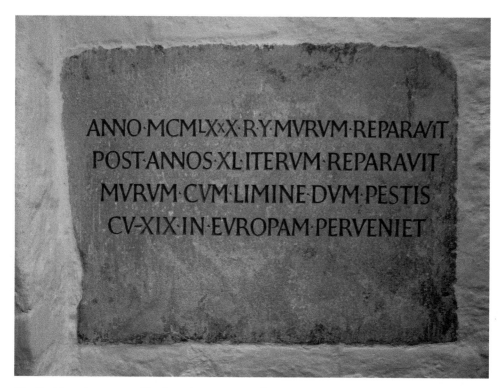

The Covid-19 plaque carved by Rory Young at 3a Park Street.

2. People

In *Hodge and His Masters* (1880) by the nature writer Richard Jefferies, the people of Cirencester (fictionalised as Fleeceborough) are portrayed as 'a nation amongst themselves'. Turning now to fact, this description appears most appropriate when one considers the range of people commemorated in the parish churchyard. They include the midwife Sarah Avery, who died in 1833 after providing thirty-seven years of service: '... in nature's trying hour / Through heat and cold by day and dreary night / To save the hapless was my soul's delight'. Their individuality of character is also reflected in the following stories of selected individuals, who were either born in Cirencester or made significant contributions to the town – from female astronomers to intrepid explorers, suffragists to classical composers.

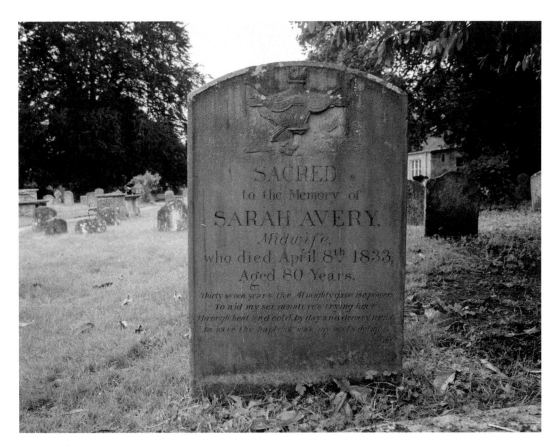

Sarah Avery's gravestone.

> **DID YOU KNOW?**
> The actor David Niven (1910–83) lived on a Cirencester farm during his early years. One of his earliest memories was learning that his father, William (commemorated on Cirencester's War Memorial), a lieutenant in the Berkshire Yeomanry, was killed in action at Gallipoli in August 1915. Another vivid memory was being used as a model by Voluntary Aid Detachment nurses who practised their bandaging skills on him at the Cirencester hospital.

Joseph Howse

Described as 'adventurous, tough and intelligent', Joseph Howse (1774–1852) combined fur trading, exploration and linguistic scholarship in his remarkable career. Born in Cirencester, the son of a brazier, initially he became apprenticed to a local bookseller and stationer. In 1795 he left Cirencester for Canada to work as a factor for the Hudson's Bay Company (HBC), probably inspired by Cirencester-born Joseph and Thomas Colen who, earlier, had joined the HBC. Once in Canada, through his endeavours to open up new trading opportunities he became the first HBC employee to cross the Rocky Mountains, a pass, river and peak subsequently being named after him. Whilst there, he also learned the native Cree language, which led him to write a highly acclaimed grammar book of the language. Still regarded as the definitive work, it was printed in Cirencester in 1844, twenty years after Howse returned to live in the town.

The Brewin Brothers

Some of the town's most interesting characters during the Victorian period were three brothers from the same Cirencester family. The eldest, Robert Brewin (1805–89), a coal merchant, who often wore old-fashioned pigeon-tail-style-cut coats, lived in Querns Lane House. Together with his wife, he often rode in a low carriage, allowing the ponies to travel at their own pace. Today, he is best remembered as an avid supporter for the prevention of cruelty to animals, appointing an inspector (later given the status of a police constable) for Cirencester and the surrounding area to enforce the humane treatment of animals and establishing the Cirencester Independent Association for the Prevention of Cruelty to Animals, which still operates as a charity today, making annual grants to animal welfare organisations. Another part of his legacy was the siting of drinking troughs at various locations in the town, as well as the humanity he showed towards the plight of shorn sheep. To ease their suffering during severe Cotswold winters, he supplied woollen jackets (measuring 36 inches long by 40 inches wide) at cost price from his Querns Lane warehouse, advertised as 'Bound all round with Tape, with Eight Strings of Tape and a Collar fitting to the neck'.

The middle brother, Thomas Brewin (1809–78), of tall and lanky build, was also kind towards animals, his long legs almost touching the ground on the slow-trotting small pony he used to ride around town. Remembered most for his strong support of the temperance movement, his campaigns included championing the supply of pure drinking water. In a letter to the *Wilts and Gloucestershire Standard* in 1864 he wrote:

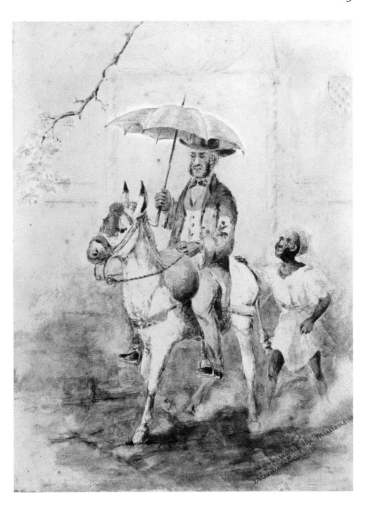

William Brewin, in
Alexandria en route for
India.

> The money wasted in Cirencester on strong drink, in a single week, would pay for
> deepening all the wells in the town, and I confess I should feel it discreditable to be the
> owner of any house not supplied with plenty of pure water. The Romans placed our town
> where it is by nature so excellently watered, that we need not any distant waterworks to
> supply us, and if we allow our wells to be either dry or polluted it is our own fault.

The younger brother, William Brewin (1813–82), was a Quaker who travelled widely on
missionary visits, particularly to India, Egypt and Palestine, but also to Jamaica, following
which he co-authored the book *Jamaica in 1866* (1867) with Thomas Harvey, providing a
commentary on the country's socio-economic conditions and state of its schools. Almost
invariably, when he returned, he gave talks on his travels with equal missionary zeal,
seeking 'to awaken in [his listeners] a desire to know more of these ancient places'. Like
his two other brothers, one of the enduring images of him, now hanging in the Friends'
Meeting House in Thomas Street, is a painting showing him on horseback, travelling at a
gentle pace, with a kindly disposition.

DID YOU KNOW?

Edward Jenner (1749–1823), the pioneer of smallpox vaccination, attended Cirencester Grammar School. Here, he excelled in classics and showed interest in natural history through collecting highly regarded fossil specimens from the oolite. Another remarkable medical pioneer, Dr Edgar Hope-Simpson (1908–2003), ran a popular Cirencester general practice surgery alongside working as a pathologist at Cirencester Memorial Hospital from 1946 to 1976. Around this period, he also undertook groundbreaking research in his virus laboratory, called the Cirencester Research Unit, which led to important discoveries, including the connection between the shingles and chickenpox virus, and the transmission of influenza.

Cirencester's Remarkable Astronomer

For the final sixteen years of her life Cirencester-born Elizabeth Brown (1830–99) was one of the leading amateur astronomers of the day, making important contributions to the research of sunspots and also undertaking intrepid journeys to far-flung places to observe solar eclipses. Born at Further Barton, Hampton Road, Cirencester (whose grounds adjoin the farm of the Royal Agricultural College), Elizabeth was the eldest daughter of the wine merchant Thomas Crowther Brown and his wife Jemimah who tragically died

Further Barton, once the home of Elizabeth Brown and her two observatories.

before Elizabeth was eleven. Sharing her father's passion for science, Elizabeth was taught by Thomas how to observe meteorological phenomena and use a small telescope to observe Jupiter's satellites and Saturn's rings. From 1871 she took responsibility for the daily recording of rainfall for the Royal Meteorological Society which her father, an amateur meteorologist and Fellow of the Geological Society, previously carried out. She also contributed measurements of temperature, thunderstorm and deep-wells for a time. It was after Thomas died in 1883, freeing her from the duty of caring for her sick father, that Elizabeth was able to concentrate on astronomy.

The considerable wealth bequeathed by her father allowed Elizabeth to travel extensively. She made regular 280-mile round trips from Cirencester to attend meetings of the then flourishing Liverpool Astronomical Society. She was their first female member, served as director of the Solar Section from 1883 until 1890, and contributed observations on the changes in star colours. She had two observatories at home, one which housed her meteorological instruments and another, in the grounds, where she used her clock-driven telescope to project the Sun's image onto white card and then made drawings of any

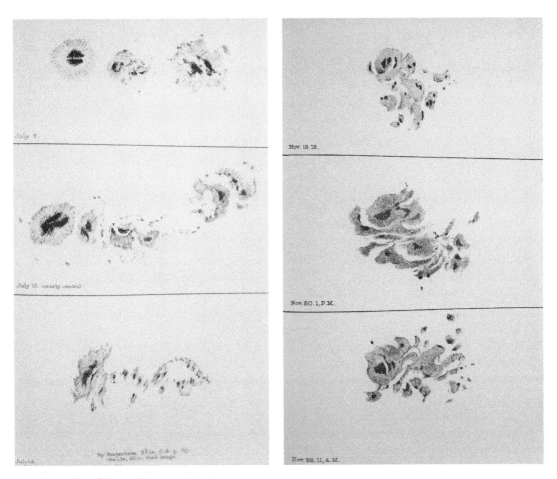

Examples of Brown's Sunspot Drawings.

sunspots present. In the late 1880s she made two adventurous trips. The first, published anonymously in her book *In Pursuit of a Shadow* (1887), recorded her trip to Kineshma, around 200 miles north-east of Moscow, 'to see the great Solar eclipse of August 19', while a second, *Caught in the Tropics* (1890), described her expedition to Trinidad where, on 22 December 1889, she and her lady companion saw, for a short time, 'the silvery light of the corona encircling the death-like blackness of the moon's orb ...'.

In our current age, almost totally deprived of dark skies, it is interesting to note that Elizabeth occasionally observed the *Aurora Borealis* in Cirencester. Perhaps the most impressive occurred on 31 January 1881 when she saw the following:

> ... an arch of white light clearly defined, from which pale white rays shot up at intervals. The arch extended from beneath the Great Bear to beyond Cygnus. These white streamers presented two distinct appearances, at times shooting up in single rays, at others passing from east to west in almost parallel columns.

Equally exciting was her observation in daylight, whilst watching Venus, of a spectacular meteor shower on 18 September 1895. Estimating that more than a hundred passed, she described them being 'of silvery whiteness, and [varying] considerably in dimension'. Apart from her astronomical records she also made many local observations about nature and meteorology. These included curiosities such as the discovery in her garden of around eighty-five wild bees' nests in an area of 60 square feet; and a neighbouring farmer's ordinary hen which laid a huge egg 'measuring 4½ inches in length by 7 inches in circumference', inside which was 'a second perfect egg, with hard shell of ordinary size (3 inches by 5½ in circumference)'. She also recorded spectacular sunsets and dramatic colour effects in the sky following the huge volcanic eruption on Krakatoa in 1883; and the sight of an aerolite, dug up 13 miles east of Cirencester and, subsequently, deposited in the British Museum. In other published articles she encouraged those interested in astronomy to achieve higher levels based on her own personal experience of possessing 'the two most necessary qualifications – accuracy and perseverance'.

In 1890 she became, *ex officio*, a founding member of the council of the newly formed British Astronomical Association (BAA), contributing to the Solar, Lunar, Variable Star and Star Colour sections. For the next seven years she produced a series of annual reports which, as *The Times* commented, 'involved an immense amount of personal labour, undertaken most cheerfully, without the slightest desire for distinction or fame'. Here, her artistic skills proved invaluable, coupled with her accuracy, precision, and attention to detail. In 1893 she became one of the few early women to be elected as Fellows of the Royal Meteorological Society. A year earlier, she had been put forward for election to the Fellowship of the Royal Astronomical Society. Nevertheless, at this time none of the female candidates were successful.

In May 1894 she visited the Madrid Observatory where she expressed 'regret that the splendid climate of Spain cannot be better utilised'. A third eclipse expedition was made with the BAA in 1896 to Vadsö, northern Norway. Three years later, as she planned a fourth eclipse journey to Spain or Algeria in 1900, she died suddenly of cardiac thrombosis.

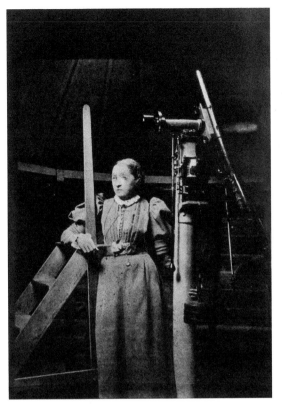

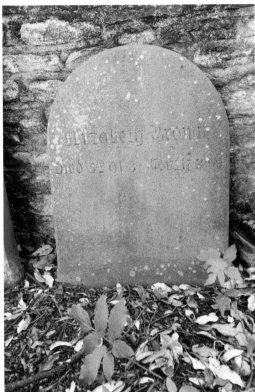

Above left: Elizabeth Brown in her observatory.

Above right: Elizabeth Brown's tombstone in the garden of the Friends' Meeting House.

As a devout Quaker she was buried in the Friends' Meeting House burial ground in Thomas Street. At her death the value of her property exceeded £35,000. In her will she left £1,000 to the BAA, together with her astronomical observatory and its contents. She also left donations to national and local charities, including the Cirencester branch of the Society for the Prevention of Cruelty to Animals. Remembered for her calm, gentle and unassuming nature, she was also generous, regularly financing a Christmas morning breakfast for approximately thirty clerks and postmen at Cirencester Post Office.

Grace Hadow

Another remarkable woman was the author, academic and social campaigner Grace Hadow (1875–1940), remembered in Cirencester, principally, for her role supporting the emancipation of women. Born at the South Cerney vicarage, by the time she was studying English in 1900–03 at Somerville College, Oxford, although she could sit the exams, as a woman she was not allowed to receive her degree. When she moved to Cirencester in 1907, staying at Fosse Lodge (25 Sheep Street), to care for her ailing mother, whilst working as a part-time tutor, the town was generally not supportive of the women's

suffrage movement. Hadow's biographer, Helena Deneka, summed up this parochial environment:

> The little town was then very much cut off from the outer world ... It was an agricultural and sporting world where the instinctive response to cultural values was incomprehension. Brains were disliked, especially in women.

Family conversations in Cirencester would have proved, at times, challenging since Grace's mother and brother held anti-suffrage views. Despite this, Grace held her ground and, in July 1912, became secretary of the newly formed Cirencester branch of the Women's Suffrage Society (WSS). Soon, her strong organisational ability became evident. On 16 July 1913 she arranged one of Cirencester's largest political rallies when a contingent of the Women's Suffrage Pilgrimage gathered at the Market Place, comprising peaceful protesters marching along various routes to London. Although one report estimated a crowd of 3,000 to 5,000, a more conservative figure seems likely given its physical layout. While the Principal of the Agricultural College had instructed potential student troublemakers to stay away, a band of young men arrived, dressed in fancy dress, which acted as a signal for jostling and fighting to start. The *Gloucester Journal* reported:

> Ladies lost their hats and other portions of attire, and men their heads and feet, and possibilities seemed ugly.

Afterwards, one woman was nearly killed, and others ran to the police station for protection. Unable to hold the meeting, the suffragists decided to try again at Watermoor, but the ruffians followed their wagonette along Dyer Street and Victoria Road, prompting the driver to divert to Chesterton. As they attempted to cross a canal bridge the ruffians tried to overturn the wagonette into the water. Then, driving towards Siddington, the driver was forced to use his whip on the mob as they attempted to seize the horses' heads. After arriving at Siddington, the ladies found safe haven with some cottagers, and, later, received further protection from two policemen. Despite experiencing this ordeal, nine months later, Grace reported that the incident had led to nearly a doubling of the WSS membership. By then, she had made a name for herself as an outstanding speaker, making compelling and articulate cases about why women should have shared and equal responsibility for government. The *Cheltenham Chronicle* reported:

> She pointed out that the Government was trying to pass measures which vitally affected millions of women. Home Rule, they were told, would probably plunge the country into civil war, and through that women would suffer. Their husbands and sons would go out to war and perhaps death, and the roofs of their homes might be burned over their heads. Yet women were not to have voice in the matter!

During the First World War, Grace made further valuable contributions locally, including, in July 1916, founding the Cirencester Women's Institute (WI) after hearing Madge Watt

Grace Hadow (left) during a US lecture tour, 1938.

give a lecture on the benefits of the Canadian WI. The following year, after the National Federation of Women's Institutes was formed, she served as vice-chair, a position she retained for the rest of her life. Grace also contributed much to the cultural life of the town. She used her contacts to organise prestigious concerts, including, in February 1914, arranging for the violin virtuoso Madame Soldat-Roeger, whom Brahms considered 'as good as ten men', to give a memorable performance in the Assembly Rooms.

Peter Maxwell Davies (1934–2016)

Apart from those born in the town, Cirencester has also attracted many noteworthy visitors, either to enjoy its beauty or reside there for work. One of the most remarkable in the latter category was the renowned composer and conductor Peter Maxwell Davies. In 1959 he was appointed as music master at Cirencester Grammar School, a position he held for three years. 'I learned more about liberation through music from the Cirencester children', he commented in a 2005 Royal Philharmonic Society (RPS) lecture, 'than they ever learned from me'. At the 500-strong mixed-gender school he established both main and junior orchestras and a small choir that could be expanded to 200 for large-scale

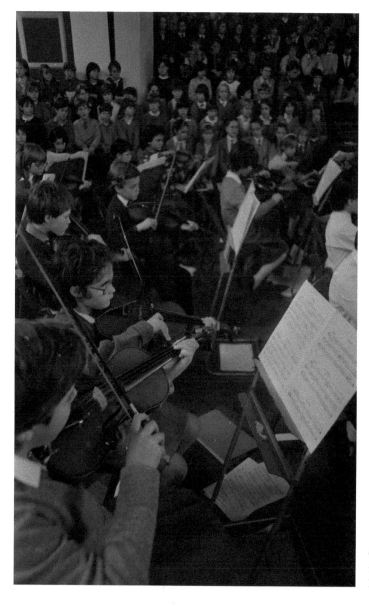

One of the school festivals organised by Davies, c. 1962.

performances such as Monteverdi's Vespers. He encouraged his students to compose their own pieces for the resident performing groups, whilst also ensuring they were adequately challenged. Rather than giving them what he considered were overly simplistic standard works, he adapted pre-Classical pieces for them. These were short, therefore requiring lower concentration levels, and had strong rhythms and tunes. Commenting, again, in the RPS lecture, he was struck by the extent to which the music he helped to create provided 'a healing and binding element, both in the school, and in the town': in particular, he believed

Peter Maxwell Davies.

the experience of collective music-making significantly enhanced the children's mental, physical and social skills.

Almost one year following his appointment, Davies started to produce a series of compositions for the school. 'O Magnum Mysterium' (1960), one of the best-known, was first performed at the parish church on 8 December with the Cirencester Grammar School Chorus and Orchestra. It comprises four carols for unaccompanied mixed chorus with two instrumental sonatas and organ fantasia. While working with amateur orchestras and choirs might have been viewed negatively by many up-and-coming composers, to Davies, it provided valuable 'insight into certain very basic musical problems and concepts, which [he felt] one is wiser – and sometimes sadder – for knowing something about'. Even after reworking parts of Monteverdi's Vespers for the school choir and orchestra, he considered he got nearer to the true sound and spirit of the original than would have been the case had he worked with fuller orchestration and been able to produce a 'purer' performance. Greatly encouraged by Benjamin Britten, another significant advocate for the teaching of music, Davies believed passionately in music's integral role in education. Once, when taking his students to hear some new musical offerings at the Cheltenham International Music Festival, he recalled how they made more perceptive comments than the newspaper critics. Although his posting at Cirencester was relatively short-lived, it undoubtedly proved significant in his career and, in many ways, laid the foundations for his educational work when he moved to the Orkney Islands in 1971, where he continued to use the local school orchestra to premiere some of his later work.

DID YOU KNOW?

In 1821 the political journalist William Cobbett passed by 'Citier' (Cirencester) while on his way to Gloucester. Describing the town as 'pretty nice', he poured his wrath out on the surrounding stony country which, he described, as 'ugly' and the most 'cheerless' he had ever seen.

3. Crime and Punishment

A range of different criminal judicial systems have operated at different times throughout Cirencester's long history. In Roman times, it fell to the elected decurions at the basilica to deal with petty crime. Punishment would have simply consisted of fines or confiscation of property since there was no policy of imprisonment in Roman Britain. During the medieval period, when the town became the centre of a hundred, Cirencester had its own court. From 1222, following permission granted by Henry III to the Abbott of Cirencester, it also had its own gaol and gallows. Occasionally, the Abbott would lend the town's gallows to his friends in neighbouring districts – a lucrative practice given that it allowed him to claim the felon's goods. Nevertheless, after one of his neighbours, Elias Giffard, built his own gallows at Brimpsfield, the Abbott lost part of this revenue stream. Although the Abbott subsequently tried to sue Giffard for his refusal to take condemned prisoners to Cirencester, the latter held firm, defending what he claimed were his ancestors' rights to hang thieves on his soil. Despite this, there were still other ways through which the Abbott could increase his income. Around 1346, for example, the Abbot (and his servants) were found to have accepted a bribe from John Heywod of Cotes to allow him to escape from Cirencester Gaol. The latter had been imprisoned there after acquiring three horses and thirteen oxen, all stolen in Berkshire.

A system of policing for the area continued under the Statute of Westminster 1285, through which constables, appointed by the hundred courts, presented serious crimes, such as assaults, and minor offences, including insults and affrays. In May 1572, there was even a case in Cirencester that recorded an assault involving a 'candelabre'. If deemed necessary, it seems likely that the guilty party would have spent time in gaol, the existence of which was documented in 1545 and, again, as 'gaile', in 1574.

DID YOU KNOW?

Thomas Syndlehurst was fined 12d on 23 April 1553 for failing to clean the pavement opposite his house in Cirencester. At the same court two other men, John Roberts and Richard Saundye of 'Instropp Street', were fined 41s 4d for harbouring unemployed 'wandering women' and 'vagrant and vagabond men'.

Quakers' Trials

While many of the cases until then were fairly routine, during the latter half of the seventeenth century some challenging new law and order issues arose through religion. Following George Fox's visit to the town in 1655, Cirencester established itself as an

Above: The Quaker Meeting House, in Thomas Street, built in 1673.

Left: Plan of the Quaker burial ground.

important Quaker centre. Then, in the light of restricted religious freedoms, many Quakers sought to defend their faith. Some were jailed in the bridewell and debtor's prison which stood, at that time, in Dyer Street, next to the Bear Inn, previously serving as a Tudor workhouse. On 13 January 1661 eighteen Friends were violently arrested during one of their meetings, the constable said to have beaten and dragged them out 'by the haire of the head'. The next day, when they were put before the judge, although there were no charges levied against them, they were still sent to the prison for their failure to swear an oath of allegiance. Other cases were heard at the Quarter Sessions at Gloucester. In September 1657 this included four Quakers – John Roberts, Robert Sylvester, Philip Gray and Thomas Onion – who had led a silent protest during the service in the parish church by standing up with their hats on. After the minister stopped the service, commenting they could not proceed 'while those Dumb Dogs stood there', members of the congregation hauled them outside. At the hearing in Gloucester, although they were held for some nights in the gaol at Gloucester Castle, an intervention from John Roberts' uncle led to their release.

Less straightforward was the case of Elizabeth Hewlings who, in 1670, died from her injuries after being thrown downstairs, the lead instigator Thomas Masters subsequently claiming that she had died from 'God's visitation', while the court's clerk refused to let the Quaker witnesses testify, commenting they 'did not deserve the benefit of the law'. Two other Cirencester Quakers were also incarcerated at Gloucester Gaol for lengthy periods. Theophila Townsend (1656–92) was initially imprisoned in 1678 for preaching, famously asking at her trial 'Is it a crime to direct people to turn from ungodliness?', to which the judge reputedly replied, 'Yes, that's enough'. Yet, for one reason and another, she was held in the gaol's abominable conditions for three years and four months. Afterwards, she published accounts of the wrongs that she and her fellow Quakers suffered. *A word of counsel* (1687) gave testimony to the harsh conditions and examples of injustice in Gloucester Gaol. This included 'an aged blind man, *Thomas Holbrowe* [who] was thrust into prison, and not brought before any magistrate', while her pamphlet *A few words to the Inhabitants of the Town of Cirencester* (1687) detailed some of her own suffering:

> ... the Constable of Cirencester, who saw me going to a Neighbours House, they run after me, and took me into Costody, and had me to the petty Sessions at Barnsley, three miles from Cirencester; in the Cold Winter Season, not considering my Age and Weakness, but hurried me up and down at their pleasure, tho they knew me a weakly Woman, and it was Frost and Snow, yet they had no Regard nor Pity ...

Daniel Roberts (1658–1727), the son of John, was also held in Gloucester Gaol in 1683 for holding a conventicle. Nevertheless, his experience seems less severe. Indeed, on one occasion he was even left in charge of the prison after the gaoler was required to attend the assizes in Oxford but lacked confidence in handing over the keys to his drunken colleague. Much to the gaoler's gratitude, while he was away, Daniel prevented a planned escape by two notorious highwaymen. Afterwards, the gaoler rewarded Daniel by complying with his requests to show greater leniency towards the prisoners, including a successful plea to reduce one inmate's death sentence to transportation.

Eighteenth and Nineteenth Centuries

While the escape plan for the highwaymen failed, in 1758 one of the prisoners who made a successful break-out, this time from Cirencester prison, was a Mr Haines. About to be transferred to Gloucester Castle to await his trial, Haines escaped without any shoes, the description of his 'Wanted' notice advising that the twenty-four-year-old's feet are likely 'hurt by walking'. Haines was being held after attempting to poison some children by giving them apple cakes laced with arsenic. His motive, following his marriage to the daughter of a farmer, who intended to divide his prosperous estate among his seven children, was to ensure his wife would gain sole possession of the estate by poisoning her six siblings. Another case around this time concerned James Millington, the keeper of the town's bowling green. On 25 October 1743 three men stole £30 in cash, four rings, a great coat, a gun and a lock from his house. Millington and his wife were both attacked, and the latter fatally stabbed. Good descriptions of the suspects were issued and a £40 reward offered. Eventually, they were all arrested. Two were sent to Gloucester Gaol, while the third, Thomas Teptoe, was held in Cirencester Bridewell to await his fate at the next Assize.

Many of the cases during this period were heard in the court that operated between 1672 and 1847 which can still be visited in the upper chambers of the Town Hall. By the late eighteenth century constables were now appointed by justices of the peace as the hundreds as administrative units diminished in importance. It was also during the late 1790s that a number of residents formed their own 'Bond of Association' to deal with a recent increase in burglaries. Established with the purpose of prosecuting at their own expense 'all persons who shall dare to commit any kind of theft or violence on the properties of the associates', they offered a range of rewards for the apprehension and conviction of offenders, from £2 2s for stealing sheep to £10 10s for burglary and arson.

Another development occurred in 1804 with the construction of a new lock-up. While the gaol in Dyer Street still existed until c. 1840, this new building, comprising two cells with a combined footprint of around 24 square metres, was built on Gloucester Street. Among the occupants within its walls of ashlar blocks was William Taylor. Imprisoned in 1825 for knocking down a soldier, the incident had also sparked off some riotous behaviour, involving some 200 people who threw stones. Another, in January 1829, was an itinerant Jew, simply referred to as 'Moses'. Arrested initially in Faringdon, he was

The courtroom in the Town Hall, which operated from 1672 to 1847.

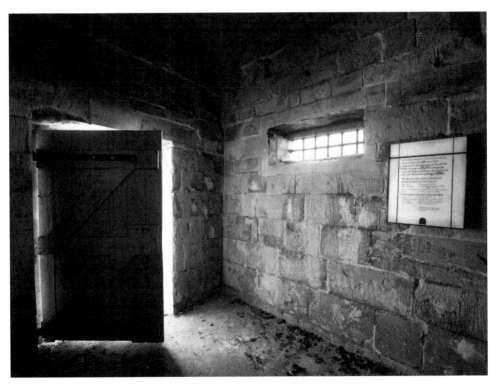

The Lock-up's interior, including one of its windows used for ventilation.

brought back to Cirencester to face charges of making fraudulent transactions. After reputedly arriving in Cirencester to sell items of jewellery, he proceeded to order meals at various inns and borrow sums of money on the pretence that his master would soon arrive to settle his account. When Mr Cox, the Cirencester constable, caught up with him at Faringdon on the Saturday morning, Moses refused to move, claiming that he could not travel on his Sabbath day. Cox, then, replied that he would accompany him to 'a place where he could be more comfortably accommodated than in the one he had passed the preceding evening'.

The following autumn, the gaol may well have been close to capacity. Like many towns Cirencester became involved in the uprising known as the Swing Riots, during which agricultural machinery and many buildings were destroyed. To counter the unrest, sparked by increasing levels of poverty and the introduction of new mechanisation, 129 townspeople volunteered to serve as special constables, twenty-four of whom operated on horseback.

In 1837 the lock-up was transferred from Gloucester Street to Watermoor. The last prisoner was reputedly William Carpenter, a well-known Ciceter character, nicknamed Billy the Bold-un. Thereafter, the lock-up was used for recalcitrants at the town's workhouse run by Cirencester's Poor Law Union. Today, it is located on Trinity Road, at the back of the Cotswold District Council offices.

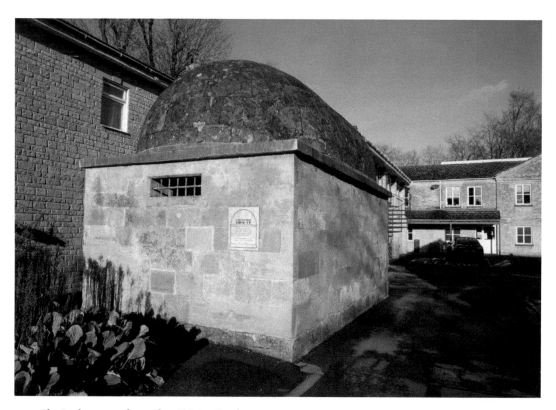

The Lock-up, now located on Trinity Road.

The town's first police station was established in 1839 in a house in Gloucester Street. An internally produced description around that time revealed significant shortcomings. Surrounded by other buildings, including a slaughterhouse, it was 'deficient in light and air' with 'any damp badly drained'. Its buildings were old and poorly maintained, and even its prison cell was deemed insecure. All in all, the accommodation was considered insufficient apart from that reserved just for the superintendent. Unsurprisingly, twenty years later, it transferred to more suitable premises, in Castle Street, which incorporated a Petty Sessional Court, and later, during the 1880s, enlarged with a County Court and Magistrates' Court. The building was also more in keeping with its status as a Divisional Station. By then, the Cirencester force was charged with policing an extensive, largely rural area, covering Northleach and Chedworth to the north, Sapperton to the west, Bibury, Fairford and Lechlade to the east, and South Cerney to the south. Among the police's early responsibilities were duties to monitor sheep fields and ensure sheep dipping was being carried out properly. On 13–17 September 1856, for example, the recorded entries for the Cirencester Station diary major on the case of a missing sheep from a farm at Coln Saint Aldwyns. Upon further investigation, however, it transpired that the sheep had disappeared two days earlier, and, simply, had strayed. After visiting the farmer, the Cirencester Superintendent, Edwin Riddiford, noted, 'there is great blame to [the farmer's] Shepherd in not counting the sheep and that [the farmer] intends discharging him'.

The old police station in Castle Street.

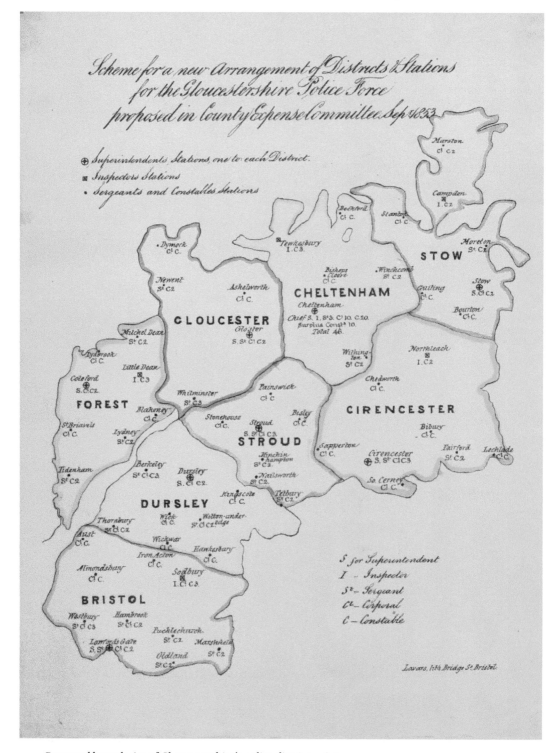

Proposed boundaries of Gloucestershire's police districts, 1853.

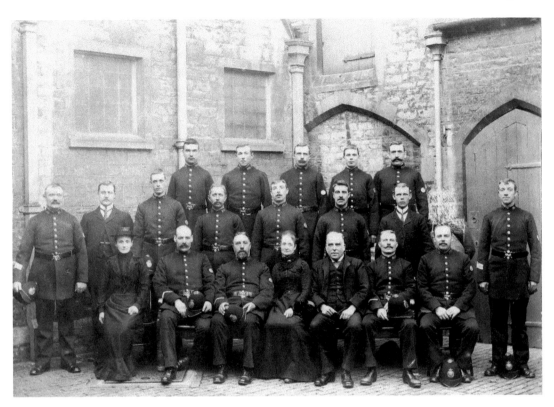

Cirencester police station staff, *c.* 1900.

DID YOU KNOW?

John Archer, a dyer, was convicted to three months' hard labour in Northleach Prison for stealing asparagus plants from a Cirencester garden on 16 May 1829. Another case, heard in February 1832, led to George Hall, a Cirencester victualler, being fined £5, and 10s costs, for allowing the unlawful card game called 'Put' to be played on his premises.

Abducting a Voter

One of the more unusual cases for the police to handle, however, concerned the abduction of a voter by the name of John Kibblewhite. Working as a road contractor, whilst living at 110 Gloucester Street, immediately prior to the 1859 election he was asked to open a drain for Henry Pole, the squire of Stratton House. Keen to fit in this job, and also attend the nomination proceedings for the election, he arrived at around 4 a.m. and completed six hours' work before attending the event in the town centre and then returning to work. Around 5 p.m. he was given some beer and then a cup of tea, noticeably dark in colour,

Stratton House, where Henry Cole lived in 1859.

which he asked to be sweetened because of its strange taste. Immediately afterwards, he lost consciousness.

Although Kibblewhite was a labourer, as a male owner of land or property worth 40s or more he was among the one-in-five of the population entitled to vote at that time. Moreover, given that the secret ballot system for elections had not yet been introduced, his preference for voting Conservative would have been widely known. With this contest aiming to elect two MPs for the East Gloucestershire constituency, it was set to be a close-run battle between the Liberals and the Tories. Yet, at around 8.30 p.m. it seemed unlikely that he would be able to cast his vote the following day. Three of Henry Cole's servants took the unconscious Kibblewhite in a carriage to Ashton Keynes, around 6 miles from Stratton, the carriage, incidentally, being spotted by Kibblewhite's wife Charlotte as it passed their house.

Feeling sick and stupefied when he woke up in the morning, Kibblewhite found himself at lodgings at the King's Head inn, Ashton Keynes, just across the border in Wiltshire. Yet, still intent to attend the polls he set out on foot after asking the landlord, David Cove, the way to Cirencester and paying him 6d for his night's accommodation. Nevertheless, by the time he got to Watermoor, Kibblewhite felt much worse, and only succeeded in arriving at the hustings after a carriage gave him a lift. Despite his determination to vote, he was taken ill and brought to the Bear Inn, where he was examined by a doctor who

suspected that he had been drugged. Remarkably, after a few hours' sleep, Kibblewhite felt well enough to register his Tory vote before the polls closed, though, for a week or so afterwards, still felt the effects of the drug (later proved to be laudanum) which had been added to his tea.

At the trial, Henry Cole succeeded in avoiding being summoned as a defendant since, it was argued, there was no evidence that he had instructed his servants to carry out this illegal act. Jermyn Coleburn, Cole's groom, Mary Coleburn, the groom's wife, and Walter Mullis, Cole's gardener, on the other hand, were all committed under the Corrupt Practices Prevention Act, despite Mr Cripps, the defence lawyer, arguing that, technically, no offence had occurred since Kibblewhite had cast his vote. Further damning evidence came to light after Jermyn Coleburn visited David Cove and paid him 15s for his help, whilst also retrieving a bottle of laudanum, meant to be used if Kibblewhite had risen too early. Jermyn Coleburn and Walter Mullis were sentenced to one month in Gloucester Gaol, the judge expressing dissatisfaction that the prosecution was directed against the servants only, and not their master. When the votes were counted, and both Tory candidates, Robert Stayner Holford and Sir Christopher William Codrington, duly elected as MPs, John Kibblewhite must have reflected on the inherent difficulties of upholding democratic principles.

Snaring Pheasants, or the Cirencester Poaching Case

Another case, occurring around the same time, concerned Thomas Hall. When he stood in rags in the dock at the Cirencester petty sessions on 7 January 1861, initially it appeared to be a straightforward poaching case. Charged with shooting a pheasant on the Bathurst Estate, Hall's guilt was quickly proven by a witness who duly corroborated the head gamekeeper's accusation. The witness had seen Hall shooting several times at the bird during the night in question, albeit without killing it. Bizarrely, as Hall explained in his defence, it was the witness, previously unknown to Hall, who knocked on his door at midnight and persuaded him to try to shoot a pheasant, even loading and giving him a rifle. Hall was subsequently sentenced to three months' imprisonment, the judge noting that he carried a previous conviction for poaching in 1858. Hall was then charged with a similar offence of shooting a rabbit on the estate. This time, the evidence was provided by the gamekeeper, who claimed he saw Hall poaching with another man. This individual turned out to be the first witness whom, Hall claimed, was the one who bagged the game. At this point, William Boodle, a Cheltenham solicitor who had been listening in as a by-stander while dealing with a different case, stepped in and asked to comment on the proceedings 'not as an attorney but as an Englishman'. Expressing disappointment that such practices were still being followed, he likened them to Jonathan Wild, the notorious thief-taker, who received blood money for the apprehension of the men he made into criminals. The case led to much criticism of the Game Laws, *The Cheltenham Journal*, for example, pronouncing them as 'an iniquitous tyranny, and their supporters as individuals of the darkest dye'. The final word belonged to *Punch* magazine, which concluded that snaring peasants was a worse crime in the eyes of *Mr Punch* than snaring pheasants.

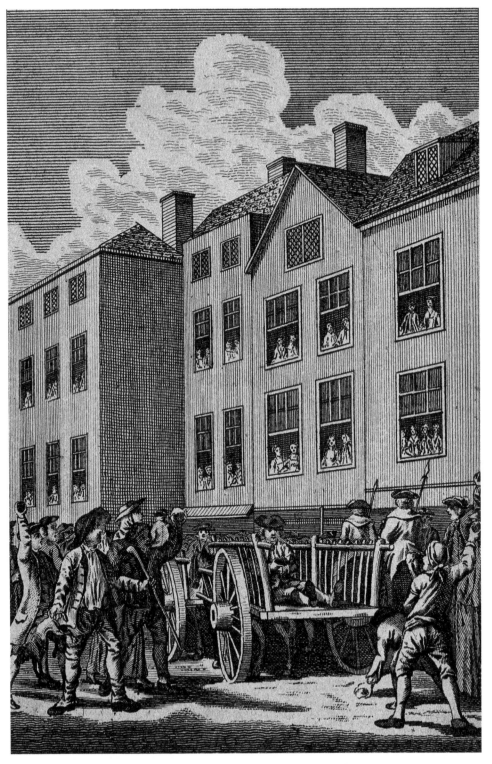

Jonathan Wild, the thief-taker, being pelted by a mob. Engraving by Valois.

The Poisoned Chocolates Case

While most of the town's criminal cases have usually disappeared into relative obscurity, one that occurred in 1925, known as 'the Poisoned Chocolates case', received more than mere parochial interest. Such was the public's fascination with this sensationalist case that it was reported far and wide – both within the mainstream and local press – from *The Aberdeen Press and Journal* to the *Yorkshire Evening Post*. The case had all the ingredients of a detective novel, and it seems more than coincidence that, four years later, whilst not set in Cirencester, the crime writer Anthony Berkeley published his classic *The Poisoned Chocolates Case* (1929). Additional intrigue centred on the violent and acrimonious relationship between George Smith and the widow, Annie Davenport of Elkstone, the latter being the one accused of posting a box of chocolates laced with strychnine from Cirencester to George's seventeen-year-old bride, Agnes Price, around the time of their wedding.

After being formally charged at Cirencester Police Court on 5 October, Annie, later, pleaded not guilty. In a manoeuvre designed to divert attention away from herself, she also claimed to have received a second box of chocolates containing strychnine through the post. Nevertheless, as the trial proceeded over the next few weeks, the full story of what really happened began to emerge. Agnes, whom George married after breaking off his relationship with Annie one month earlier, had originally eaten one of the chocolates after assuming from the gift card (signed 'From Harry') that she knew the identity of the sender; but then, finding it had a hot, bitter taste, she spat it out and washed her mouth out with water. Apart from the nasty taste remaining for some time, further suspicion was aroused when George found a blue substance after breaking one of the chocolates. Later, following an analysis undertaken by a police-commissioned specialist, the chocolates were found to contain Prussian blue, wheat starch and strychnine – the ingredients of Battle's vermin killer. Then, at the trial, a chemist at Paternoster's (then located at 170 Cricklade Street)

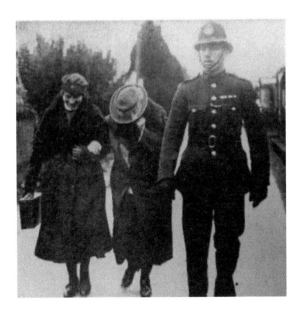

Annie Davenport and companion arriving for 'the poisoned chocolates' trial.

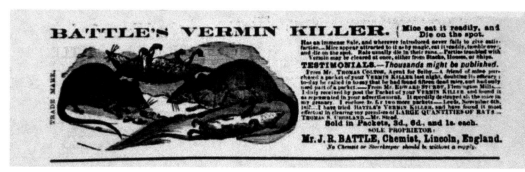

Advertisement for Battle's vermin killer from a nineteenth-century trade journal.

provided the crucial evidence that Annie had purchased the poison from the shop in May. Furthermore, the Cirencester postmaster, Alfred Trinder, also proved that Annie's claim about the second box of chocolates was false.

In the end, the jury found Annie Davenport guilty of sending poison with intent to anger, grieve, and annoy, but not guilty of causing grievous bodily harm or an intent to murder. The fact that the box contained slightly less than half a grain of strychnine proved decisive in this regard, given that half a grain was needed to kill a person, but there was only one-tenth of a grain in each chocolate affected. The ensuing headline in *The People* on Sunday 1 November summed up Annie's motive for taking this foolish action: 'Lost her lover, so sent poison. Widow's hate for rival who supplanted her'. After hearing from the Cirencester Superintendent that Annie had previously been convicted for stealing £15, the Gloucestershire Assizes' judge sentenced her to eight months' imprisonment.

Twentieth Century

Among the police reforms implemented during the first half of the twentieth century was a county-wide initiative to recognise acts of bravery. Introduced around 1919 by Gloucestershire's Chief Constable Major Stanley Clarke, the award, known as the Silver Braid, comprised a silver ribbon worn on the right breast of the officer's tunic. One of its recipients was Charles Gowing who joined the police force before the First World War, but then served at Passchendaele, where he was awarded the Distinguished Conduct Medal after volunteering to drive ammunition wagons to the Front amid heavy fire. Equally brave was his quick-thinking reaction on 12 July 1929, while on traffic duty at The Cross, to stop a runaway horse which was pulling a float. After hearing some commotion in Cricklade Street he sprinted towards the narrow end, grabbed the reins, and brought the horse down uninjured on its right-hand side. In view of his exceptional bravery, he also received £3 10s from the National Horse Association of Great Britain (now the British Horse Society).

Another reform encouraged by Clarke was the employment of policewomen, who operated on motorbikes, wearing mackintoshes and peaked caps. Initially appointed during the First World War, by February 1929 there were eight working across the county, with at least one covering Cirencester. Apart from fulfilling various duties traditionally undertaken by civilian police matrons, they also escorted female prisoners, made arrests and patrolled the local area.

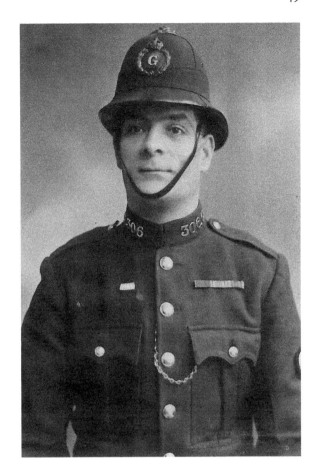

Right: Police Constable 306, Charles Stafford Gowing.

Below: Court Room 1 (Magistrates), photographed in 2020.

In 1964, when the new police station was built in the town's Forum area, incidentally unearthing the votive relief, Genii Cucullati (now housed in the Corinium Museum), which depicts three hooded spirits and a seated goddess, it included a new Magistrates' Court. While the latter only operated until 2012 due to national spending cuts, it was reopened on 25 January 2021 as one of the emergency 'Nightingale' courts commissioned across the country following the build-up of cases brought about through the Covid-19 pandemic. Today, the station still contains a prison, but, as with the town's historic lock-up in Trinity Road, it is no longer used.

Above: Court Room 2 (Crown Court), photographed in 2020.

Left: One of the redundant cells in the current police station.

4. Transport

The theme of transport has always been central to the essence of Cirencester. While the medieval proverb proclaimed, 'All roads lead to Rome', the phrase also seems particularly relevant in Cirencester's case, having been founded at the pre-Roman ancient trackway of the Whiteway (running north to Chedworth) and the axes of three important Roman roads – the Fosse Way (running diagonally from Exeter to Lincoln), Akeman Street (running east to St Albans), and Ermin Street (running west to

The milestone in Stratton on the A417 (T) Ermin Way.

A milestone on the Whiteway.

Gloucester and Wales). After flying his biplane over Cirencester during the 1930s, the writer John Moore was excited to discover the grandeur of Roman Corinium for the first time, commenting that, when viewed at 3,000 feet, the Roman roads had endured in the landscape, while the 'pusillanimous modern roads' were scarcely identifiable. Yet, even before the Roman invasion, Cirencester was considered a place 'with roads branching from it every way' by the Gloucestershire topographer Samuel Rudder, who, incidentally, is buried at the parish church. Rudder believed this was an overriding factor in the Romans' decision to establish a military fort there. He also observed that the town's location in 1800 at the centre of a network of seven turnpike roads – all largely established on pre-existing routes – reinforced its position as 'a great thorough-fare'. Within twenty-five years three more roads had been added, further strengthening its status as an important transport nucleus.

Despite the provision of this good infrastructure, travel was difficult. During the eighteenth century, in particular, journeys by stagecoach were slow and hazardous. In 1796

the thrice-weekly service to Ludgate Hill, London, departing from the King's Head inn, was only accomplished within two days, covering 45 miles per day. Moreover, passengers had to contend with high incidences of robbery. In 1763 one of the worst offenders in the Cirencester, Malmesbury and Tetbury area was arrested by chance when he visited a blacksmith's in Chalford Bottom to have his horse shod. After some locals noticed the similarity between the man's appearance and the description of a notorious highwaymen wanted for murder, they immediately arrested him, and found two pistols in his pockets loaded with lead and gravel. After being arrested and taken to the George Inn in Bisley, where he was held, the highwayman was recognised by a Cirencester man who had been robbed by him that very morning. Then, realising that he would be found guilty through the Cirencester man's evidence, the highwayman, who was eating his supper at the time, used the knife to cut his throat and, later, died.

By the 1830s numerous inns had been established in or near the Market Place to service coaches, carriers, and travellers; but, thereafter, the development of railways and, to a much lesser extent, canals, led to a decline in coach travel. Among the premier inns during the heydays of coach travel was the Ram Inn (now marked by a blue plaque), established

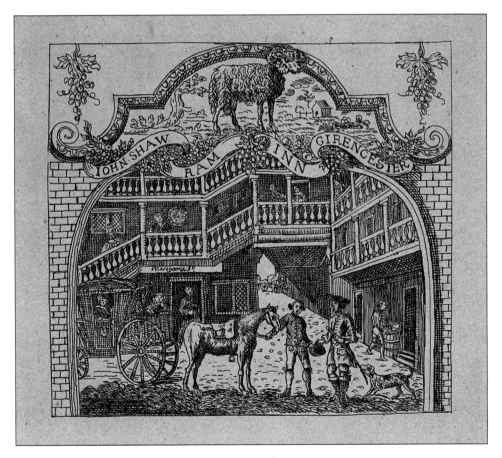

A coach at the Ram Inn. Etching after William Hogarth.

from at least 1547 but, sadly, demolished in 1895–97 when Castle Street was widened. Its lively atmosphere and attractive galleried courtyard were captured in the design for a trade card produced by William Hogarth in his early twenties when he stayed there in 1719, one of the rare instances when he travelled outside London.

DID YOU KNOW?

The name 'Akeman' is derived from 'achman', a man of aching limbs. This was noted by Daniel Defoe when he travelled to Cirencester c. 1700, observing that the street name originated from the frequency with which cripples journeyed to Bath seeking a cure. He summarised, 'So Achmanstreet was the road or street for diseased people going to the Bath'.

The Port of Cirencester

Remarkably, Cirencester once formed part of a widely connected waterway, the Thames and Severn Canal, which joined both the River Thames at its eastern end and, at its western end, the River Severn. While the ambitious scheme to unite the two rivers was enthusiastically supported by the 1st Earl Bathurst, Alexander Pope considered it a 'joke' in view of the huge engineering challenges necessary to 'Join Cotswold Hills to Saperton's fair Dale'. Yet, in 1789, fourteen years after Bathurst's death, the canal opened. Boats arrived in Cirencester via a mile-long arm from Siddington, and, when travelling from the west, transited the 2-mile-long Sapperton Tunnel, then the longest canal tunnel in the country. When four barges, laden with coal, arrived on 22 April thousands of spectators flocked to line the canal. According to press reports they 'express[ed] their joy and surprise on seeing a river brought to, and a port formed on, the high wolds of Gloucestershire'. Soon, their joy turned into increased prosperity as this important new link led to a fall in coal prices from 24s to 18s a ton.

While grain was the principal commodity that the canal helped to export from the area, timber, bricks, slate and salt – in addition to coal – formed the principal incoming goods. Among the more unusual cargo carried by barge was 300 tons of ice. Imported from Norway via Sharpness in 1877, the ice was destined for the Cotswold Bacon Factory (previously located on the western side of Mount Street), operated by Messrs Cole and Lewis. The same company also purchased barge-loads of sawdust from Ryeford Saw Mills, Stonehouse, which was loaded loose into the boats and then unloaded at one of the wharves at the canal terminus in Cirencester basin. In its heyday, the facilities included three wharves and a wharf house, once located in the triangular area (now redeveloped) between the bottom of Querns Lane and Querns Road. Yet, by 1887, five years after the canal was bought out by the Great Western Railway (GWR), serious decline had set in. While seventeen vessels completed ninety-four trips that year, only seven boats made twenty-four in 1891, by which time it was acknowledged that most of the traffic had diverted to the railway.

Today, these trees follow the canal's old course near Cirencester basin.

The old boundary wall, towpath, and canal (now filled with grass).

Railway Stations

On 1 August 1840 the *Wilts and Gloucestershire Standard* proudly predicted that Cirencester would soon become 'one of the most active and prosperous towns in the West of England' following the opening of the Cheltenham and Great Western Union Railway (CGWUR). While originally planning to link Cheltenham, Gloucester and Swindon, on 31 May 1841 only the first stretch of the CGWUR line between Swindon and Cirencester opened. Yet, during the first week of operations, daily takings considerably exceeding £100 were being made. Passengers enjoyed the possibility of being able to reach London in around 3½ hours, while the handsome station building, designed by Isambard Kingdom Brunel and his assistant Robert P. Brereton, was said to exhibit 'the busy stir and bustle of a fair'. Then, around four years later, by now under GWR ownership, Cirencester's rail links extended to Gloucester and, subsequently, Cheltenham, after it became the terminus of a branch line from Kemble.

Now, following the arrival of the railway, a wider range of goods could be sent to Cirencester. Sometimes, however, the unusual and unexpected arrived such as a 'hamper', received on 15 August 1844, containing a coffin with the inscription, 'T. W. Westropp, 20 years of age. 1838. – 8th April'. The person in question was, in fact, Thomas Johnston Westropp, originally from County Clare, Ireland, whose memory is today still commemorated by a window in St Mary's Cathedral, Limerick. Westropp had travelled to Madeira to improve his health but died there. It appears that his body had arrived in London by boat and, later, transferred to rail. Originally destined for Charlton Kings, Cheltenham, where his mother Anne lived, it seems likely that the package had been

Brunel's original sketch for the design of the station building.

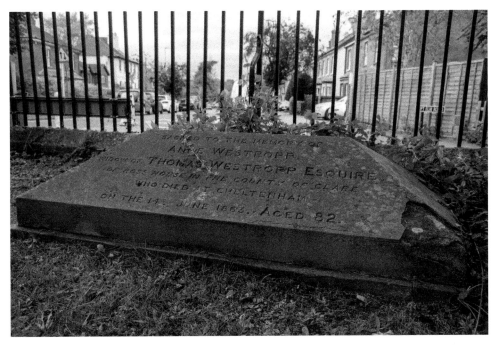

The Westropp family grave at St Mary's Church, Charlton Kings.

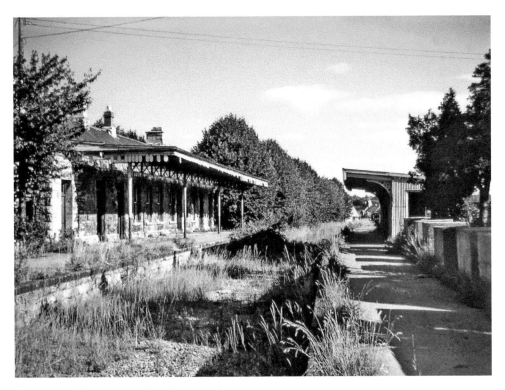

Cirencester Watermoor station, August 1967.

mis-directed. While it was said that the remains were then conveyed from Cirencester to Charlton Kings by a hearse, a further mystery subsequently arose when, following the death of Anne, Thomas' coffin was opened but found not to contain any human remains. Further traffic followed from 1883 after the opening of another Cirencester station, at Watermoor, which served the Midland and South Western Junction Railway (M&SWJR).

Cirencester Time

While the arrival of the railway brought many significant advancements, perhaps one of the least obvious to our modern eyes – viewed through the lens of instant communications – is the greater appreciation of time. In 1839, when the cartographer and publisher George Bradshaw produced the first railway timetables, he included the curious note, 'London time is kept at all the Stations on the Railway, which is 4 minutes earlier than Reading time; 7½ minutes before Cirencester time'. The schedules reflected one of the greatest challenges for the network operators at that time, namely, how to ensure passengers knew exactly when to catch their train. Although this seems bizarre to us today, in the time before electric telegraph, local time was simply set according to the rising and setting sun. Therein lay the problem: given the longitudinal differences there is a difference of around 7½ minutes between the time the sun rises and sets in

The South Porch's late eighteenth-century clock which, later, standardised to GMT.

London, compared with Cirencester. Therefore, this required timetables to manage the subtle differences, otherwise trains might be missed, or, worse still, collisions caused. In the age before steam, while minutes were of little consequence in the era of horse-drawn vehicles, they now began to assume greater importance; henceforth, rail travel provided more opportunities for long-distant appointments to be accurately planned and kept and time-critical deadlines to be more keenly observed. While individual rail companies initially attempted to standardise the time for their individual lines, eventually they agreed to follow Greenwich time. However, this was only made possible following the invention of the electric telegraph which, for the first time, enabled information to flow faster than the quickest form of transport at that time.

The End of the Line?
In April 1964, following news that Cirencester had been identified as one of the stations for closure as part of the Beeching cuts, Vera Pope, chair of the Cirencester Passengers' Association, held a bereavement party, which included the ceremonial burning of an effigy of Ernest Marples, then Minister of Transport. Three years earlier, the station at Watermoor had closed to passengers after being operational for seventy-eight years. While the town currently no longer enjoys a rail link, it still preserves Brunel's grand two-storey Victorian Gothic station building within the site of a car park. Moreover, a project to re-establish the rail link to Kemble using sustainable, low-cost Very Light Rail (VLR) technology is in the planning and consultation stage. If successful, the fair-like bustle of rail passengers alighting near the station may eventually become a reality once more.

The old GWR station building in Tetbury Road today.

5. Trade

Rather provocatively, John Moore, the Tewkesbury-born writer, commented in *The Cotswolds* (1937) that 'around Corinium Dobunorum rich men flourish like weeds'. Nearly 240 years earlier, the town's prosperity was noted by another writer, Daniel Defoe, who, when visiting the town *c.* 1700, found it 'Populous and Rich, full of Clothiers, and driving a great Trade in Wool'. Whether it was the Romans who introduced the famous Cotswold Lion sheep breed into the Cotswolds, particularly the Cirencester area, as some suggest, or whether the long-woolled breed, albeit then smaller in size, was already being farmed by the Celtic Britons may, one day, be answered through further evidence, including DNA analysis. Whichever is true, by the mid-fourteenth century the breed had helped to establish Cirencester as the principal export centre for Cotswold wool, with ten wool merchants in business by 1341. Today, visible reflections of the wealth brought by the wool trade include the magnificent Church of St John, one of the Cotswolds' great 'wool churches'; the Weavers' Hall, dating from 1483, on Thomas Street; the grand houses of former wool merchants on Coxwell Street, named after the seventeenth-century merchant John Coxwell, whilst also containing modest weavers' and wool-combers' cottages; and the mid-seventeenth-century Fleece Hotel building. Various symbols of the

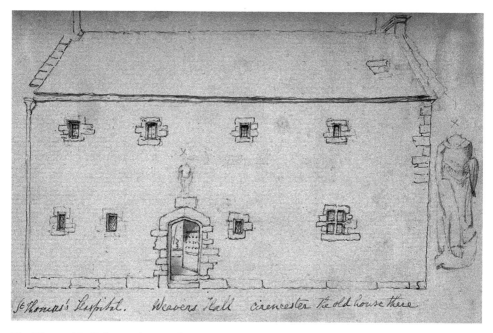

The Weavers' Hall, from a drawing by James Stothart.

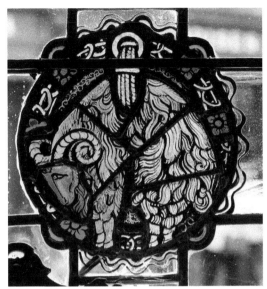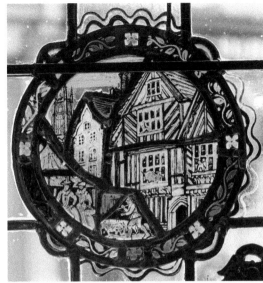

Above left and above right: Window details at the Fleece Hotel.

trade may also be noticed – from the highly conspicuous bronze ram sculpture by Jill Tweed that marks the 1980-built Woolmarket Shopping Centre to those less easy to spot, such as the brass memorial to the woolmonger Robert Page (d. 1434), shown standing on a woolpack. On the contrary, however, while Sheep Street seems another obvious link, its (corrupted) name, which derives from the Old English word *scytta* (meaning 'shooter'), probably refers to archery carried out in meadows near the old castle.

The ram sculpture.

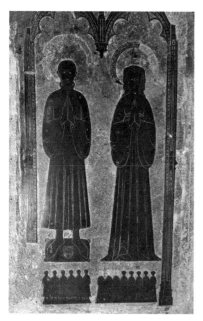

Above left: Brass memorial to Robert Page and his wife Margaret.

Above right: The merchant mark of Robert Page.

DID YOU KNOW?

The Italian merchant Francesco Datini considered that the best wool came from Cirencester and Northleach. Referring to them in Italian respectively as *Sirisestri* and *Norleccio*, Datini often used Italian buyers based in London to source the finest wool. In 1403, however, he received an apology from them for a batch of poor-quality wool obtained from Cirencester Abbey, together with the explanation that 'one must buy in advance from all the abbeys, and especially from this one, which is considered the best'.

Medieval Trademarks

Among the unusual emblems still visible in the parish church – either on memorial brasses, shields or in windows – are examples of merchants' marks dating from the medieval period. Originally used by tradespeople to label and authenticate their merchandise, the emblems were stamped onto metal discs accompanying the goods or products, in the same way that we use trademarks today. These emblems were also incorporated on shields. While the merchants and trading classes were forbidden from using heraldic insignia, the shields became recognised as their 'coat of arms', giving them a professional identity. Some marks identify the merchants through initials contained within their monograms, as illustrated by the wool merchant Henry Garstang (d. 1464).

Above: Henry Garstang's merchant mark, near his tomb.

Right: John Benet's merchant mark (located in the Lady Chapel).

His mark can be seen in three places: at his tomb in the wall at the east end of the south aisle, in the east window, and above one of the nave pillars. It is thought that Garstang moved to Cirencester from Lancashire around 1420. Here, he made a considerable fortune, bequeathing some of it, including 'all the timber in the meadow next to the Fosse [Way]', to help repair the parish church. Among the other merchants also identifiable, though their marks exclude their initials, is John Benet (d. 1497). This wealthy Cirencester dyer, who, at one time, owned thirteen servants and apprentices, set up a watermill and houses for cloth-workers at Rodborough, where wool was transformed into dyed cloth after undergoing the fulling, dyeing and shearing processes.

Brewing

Another local trade with strong medieval origins is brewing. In 1380, according to poll tax returns, brewers (then numbering nineteen) formed the fourth commonest occupation in Cirencester after servants, labourers and tailors. The town's long tradition of brewing, which largely occurred in small brewhouses attached to local inns, took a significant change from the 1790s when the Bell Inn (in existence in Cricklade Street from at least 1540) moved to a building (now occupied by Savills estate agent and still displaying its bell-shaped sign) at the corner of Cricklade Street and Castle Street. Following this move an industrial-scale brewery was founded in 1798 at the old premises of the Bell Inn, which, by 1865, had expanded to become the town's largest employer. Its success was partly fuelled through the ease of importing barley and hops via the newly established canal link but also through a copious supply of water provided by a local well. However, it was not all plain sailing. In November 1849 it was widely reported that one of the brewery's employees had a terrible fright when, upon looking under a large vat, 'he saw two fierce eyes glaring upon him'. The culprit proved to be a badger, probably an inhabitant from Stratton or Baunton woods, and was quickly 'taken into custody'. Nevertheless, four years later, it was the brewery itself that was judged to be at fault when, in October 1853, the accumulation of months'-worth of putrescent hops at the site was criticised as 'the Monster nuisance of Cirencester'. While the brewery traded as Croome, Cripps & Company by 1820, it became known as the Cirencester Brewery Ltd from 1887 to 1949,

The well, once used by the Cirencester Brewery.

Cirencester Brewery bottles.

its surviving buildings now housing New Brewery Arts. Although facing competition from other local breweries, notably the Cotswold Brewing Company operating from premises on Lewis Lane, by 1882 the Cirencester Brewery had bought out the latter and, by 1920, acquired ninety-two licensed premises within a 25-mile radius of the town. Today, although large-scale brewing has ceased, the tradition of craft breweries is kept alive. Sometimes, this is 'blended' with aspects of the town's heritage as, in 2015, when Corinium Ales Ltd called its new ale 'Bodicacia' to commemorate the discovery of the namesake's Roman tombstone on a garage site.

Edge-tool Making

Among Cirencester's more unusual industries was the production of hand- and machine-forged tools, using grindstones driven by animals or human power rather than waterwheels. Principally occurring during the third quarter of the eighteenth century, the trade was noted by Samuel Rudder who, in 1800, particularly praised the town's skills to produce 11-inch-long curriers' knives with edges 'as strong and sharp as a razor'. Widely exported across Europe and America, these products, he commented, could not be matched for quality by manufacturers elsewhere. This tradition extended to agricultural machinery and, in one case, demonstrated considerable innovation. Mr Radway, of Cirencester, became well-known as the inventor of a skim-plough, featuring a 13- or 14-inches-wide share, which could turn 2 acres of turf a day, using two horses; a skim-and-go-deep plough, capable of paring off turf to then cover it with at least 4 inches of mould; and a powerful chaff cutter, which used two knives and could

Above: *A Celebration of Hands* sculpture by Rory Young at New Brewery Arts.

Left: Examples of recently invented implements *c.* 1810 when Radway was active.

be operated by three women to produce sufficient chaff in one day to feed eighty oxen. Yet, on 14 August 1806 Radway almost lost his entire business when a fire broke out in his workshops in Cricklade Street, damaging the buildings and destroying many of the recently manufactured implements. A lit candle, carelessly left in the stables, was to blame; thankfully, however, a gentle wind prevented the flames from spreading too quickly.

DID YOU KNOW?

The Addo AB company, which manufactured mechanical and, later, electronic, calculators, established a factory in Cirencester in 1950. Founded in Malmö, Sweden, in 1918, the company is now a subsidiary of Facit. In recognition of the number of jobs created by the company in Cirencester, which was run by a brother of Hugo Agrell, the company's founder, one of its senior representatives once received the ceremonial keys to the town.

The Addo factory, Love Lane, 1960s.

The Market Town

While various trades have prospered and declined at different times, its flourishing markets have remained a constant theme throughout its history. Indeed, such was Cirencester's importance as a market town that, by 1712, it boasted two separate markets, one on Mondays for corn, cattle and general provisions, and the other on Fridays for wool, meat and poultry. The wool market, noted then by Sir Robert Atkyns as the largest

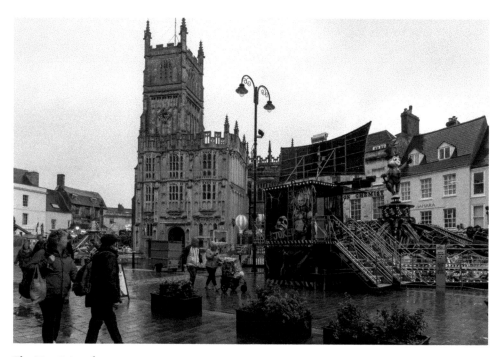

The Mop Fair today.

in England, was initially held in Dyer Street, originally known as Chepyng Street (from the Old English word *ceping* for market) but transferred to the Boothall (now the site of the Corn Hall) during the eighteenth century. The other market, already established at the time of Domesday, was held in the present-day Market Place and Dyer Street area. During the thirteenth and fourteenth centuries some temporary market stalls, located between the front of the church and the King's Head Hotel, were replaced by tightly packed rows of houses and shops reflecting their distinctive trades. These included Shoe Lane, Butter Row and Botcher Row (probably deriving from the archaic term for a tailor rather than butcher). By the 1830s, however, the area had been cleared and, today, still provides a wide open space for weekly outdoor markets. It also accommodates part of the annual mop fair, originally held for hiring servants who displayed emblems (known as mops) on their lapels to indicate their trade, but now run as a fun fair.

DID YOU KNOW?

As part of the effort to recycle metal during the Second World War, Queen Mary reportedly picked up a metal object by a road near Cirencester and transported it to Badminton in her Daimler. A week later, a farmer knocked on her door asking for the return of his plough.

6. Leisure and Entertainment

While many of the typical elements of a town's social history are usually reflected in the standard changes occurring across the leisure and entertainment sector over the centuries, there is much that is unique, unusual or unexpected in the case of Cirencester. As early as the second century AD, for example, 8,000-strong crowds of townspeople and visitors travelling from far afield thronged to the amphitheatre (located just outside the walls of Roman Corinium) to enjoy spectacles such as bear-baiting, gladiatorial contests, dog-fights and public executions. Yet, by AD 408, as the last contingents of the army departed from the city, the amphitheatre ceased fulfilling its original function. Instead, in the absence of patrons able to support public entertainment, it was converted into a fortress as community leaders prioritised protection of the town over pursuit of pleasure. Consequently, the amphitheatre's entrances were narrowed and a ditch constructed around its southern perimeter. Rather than welcoming visitors, it now sought to keep potential invaders out. Then, abandoned for many centuries thereafter, it was later used

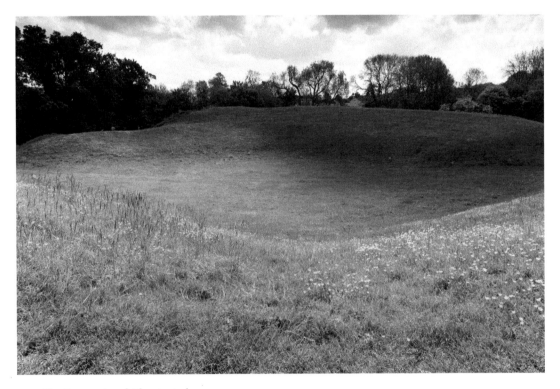

The Roman Amphitheatre today.

by the Abbot of Cirencester as a rabbit warren during the Middle Ages, as well as for bull-baiting in the eighteenth century, leading to its local name of 'The Bull Ring'. Today, its history turns full circle as the District Council starts to implement plans to return the amphitheatre to become a regular venue again – this time for concerts and plays but also historic re-enactment events and more novel ones, such as escape room-style games.

DID YOU KNOW?

Cirencester's theatrical tradition dates from the early eighteenth century. Among the early theatrical spaces was a yard in the Three Cocks inn (once located just off the Market Place in Castle Street), a purpose-built theatre (location unknown) of 1794, and a new theatre, located in Gloucester Street, which was opened in 1799, later becoming the Loyal Volunteer (now a private house at No. 27). Among the visiting actors was Sarah Siddons who, in 1807, had the audience 'repeatedly in floods of tears' for her performance as Mrs Beverley in *The Gamester*.

Historic Parkland

If a repurposed Roman amphitheatre is not unusual enough what about the Grade I listed formal parkland that was originally conceived as a private idyll but now functions as a vast open green space, currently (at the time of writing) freely accessible to the public? The initially planned 5,000-acre estate evolved through the synergy and collaboration of three remarkable individuals: Allen, 1st Earl Bathurst (1684–1775), the energetic estate owner; Stephen Switzer (1682–1745), the designer and garden writer; and Alexander Pope (1688–1744), Bathurst's friend and the leading poet of the early eighteenth century who also designed classical landscapes and gardens. In 1722 Pope described himself as 'the Magician' of the park's 'enchanted forest', helping to put in place one of the country's first experiments in landscape design, as avenues were opened up, trees planted, glades cut and features such as ornamental buildings and a lake incorporated. Like Pope, Switzer favoured a simple, natural style. In particular, he advocated what he termed 'extensive or forest gardening'. Writing in his *Ichnographia Rustica* (1715–18), he explained how this met his clients' needs:

> ... [here] the Owner may [walk] ... in his Night Gown, and Slippers and visit all his Affairs, either late at Night, or early in the Morning, without either Dirt; or Dew. [...] [and] walk four or five Miles ... without going over one Walk twice, and by little Gardens, Seats, and other Ornaments; he has as great a Pleasure as one that enjoys the noblest of Gardens.

While Pope's future vision for the park envisaged incorporating a palace and glittering pavilions adorned with colonnades, Bathurst developed the estate less ostentatiously, designing it more to celebrate nature's unadorned beauty than show off his personal wealth. With this precept in mind, it seems appropriate that the most spectacular view

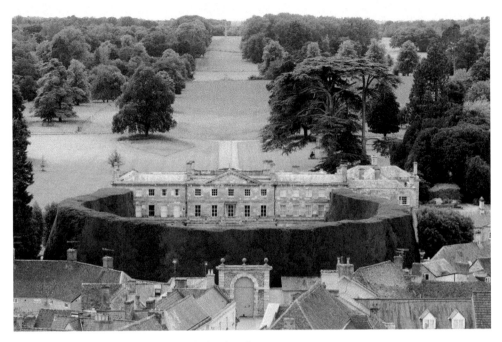

Cirencester Park from the top of St John's Church Tower.

of the park is afforded from the top of St John's Church tower rather than the estate's mansion; and, today, it serves as a relaxing rural retreat for the whole of the town's population, not just a single family.

The Oldest Polo Club

Equally unusual and unique is the fact that Cirencester Park is home to the oldest established polo club in the UK. It was officially founded on 9 June 1894, shortly after a match played between officers of 4th Battalion Gloucestershire Regiment (then commanded by Seymour, the 7th Earl Bathurst) and civilians on steamrolled ground near the Gothic-style Ivy House (now Ivy Lodge). Given the newness of the game to the area, the club devised its own rules, which included the stipulation that ponies should not exceed 14 hands 2 inches (lower than what is allowed under current regulations today). Initially, the standard of play was relatively slow as the club found its feet, but, within a few months, much livelier action was on display, the *Wilts and Gloucestershire Standard* reporting that some ponies resembled thoroughbreds while galloping 'like miniature race horses'. Although the pace impressed, there appeared some concern about the team's behaviour: during the 1896 annual tournament another local reporter observed:

> The play of the visitors was quiet but very steady. We think the Cirencester Club may learn a useful lesson by watching their visitors, there being all through an entire absence of the shouting and noise which a portion of the home team appear

to consider an essential part of the game of polo, but which does not appear to visitors at all necessary, and which we have never heard at any other ground we have visited.

Whether club members consciously attempted to control their passion is not recorded, but it soon became apparent how quickly they won over both knowledgeable *aficionados* of the game and, through events such as gymkhanas, members of the local community who started to take increasing interest and pride in the club's development. While fortunes wavered occasionally, including when the hallowed Ivy Lodge pitch was ploughed up during the Second World War to grow potatoes, polo at Cirencester is, today, recognised as 'the embodiment of country polo at its best'. The number of world-famous players and influential figures it has attracted over the past 127 years speaks volumes – from representatives of the modern game's ancestral nation, India, such as the maharajahs of Jaipur and Jodhpur, to members of the current British royal family. While the club's associations with the latter are well-known through high-profile visits made by the Duke of Edinburgh during the 1960s and, later, by Prince Charles and his sons, the first connection was made in 1922 when Edward, Prince of Wales (later King Edward VIII) participated in the club's twenty-fifth annual tournament. The event required the rare deployment of mounted policemen at the park and the cancellation of Cirencester's cricket match against Fairford. Despite the prince's request to keep details of his visit private, crowds lined the streets to see him arrive at Oxford House, London Road, where he also

Fierce competition as Emlor and Vikings compete for the 2021 Warwickshire Cup.

The Vikings, victors in the Warwickshire Cup.

stayed during occasional subsequent visits. On these occasions he was accompanied by his equerry Edward ('Fruity') Metcalfe, who, later, following the king's abdication, became best man at his wedding to Wallis Simpson. On his first visit, while playing alongside several distinguished players and characters of the game, including Major Frederick Barrett, a gold medal-winning Olympian, nicknamed 'Rattle' after breaking numerous bones through falling off horses, the prince succeeded in scoring a goal for The Templeton team. Famously, he also won a pony race in the gymkhana.

Special Events and Exhibitions

Another way in which polo was introduced to the general public was through holding matches as part of other special events. In 1894, for example, the Oddfellows Fête charity event, held at Cirencester Park, drew in around 20,000 spectators eager to witness the remarkable performance of the seventy-year-old Charles Blondin, born Jean François Gravelet (1824–97), famed for his daring crossings of the Niagara Falls on a tightrope and, later, even using stilts. It was the funambulist's fifth and last visit to Cirencester, during which he performed several amusing feats, including cooking an omelette (later conveyed to Earl Bathurst's carriage with a bottle of champagne), carrying his agent on his back, and riding a bicycle. While Blondin proved a difficult act to follow, the German high-wire walker Jean Weitzman did his best to surpass the Frenchman three years later, at the same event, by incorporating fireworks into his daredevil high-altitude routine. This time, the artiste was 'enveloped in a perfect blaze of fire', receiving rapturous applause on finally reappearing through clouds of smoke.

Above left: One of the daring walks which led to Blondin's fame.

Above right: Madame Tussaud. Photograph after a drawing attributed to Francis Tussaud.

Assembly Room, King's Head, the location of the 1832 exhibition.

Apart from these outdoor events, one of the more unusual to take place indoors during the first part of the nineteenth century was Madame Tussaud's travelling exhibition of waxworks. On two occasions, in 1824 and 1832, the enterprising artist targeted Cirencester as one of the more prosperous middle-class towns in the country where people had sufficient disposable income to attend the exhibition. In 1824 the main attractions centred on two tableaux representing the coronations of King George IV and Napoleon Bonaparte but also included the figure of Mary, Queen of Scots abdicating the Scottish crown, copied from a painting then held at the Palace of Holyrood. In February 1832, while the exhibition still included much to please monarchists through depicting William IV's recent coronation, the greatest attraction was of the Chamber of Horrors variety, displayed in a separate room, featuring the bodysnatching murderers Burke and Hare. Madame Tussaud, who employed her two sons in the business, went to strenuous lengths to achieve the most accurate attention to detail; in this case, she went to Edinburgh to model William Burke at his trial in December 1828, while her sons obtained a cast of Burke's head almost immediately after his execution on 28 January 1829. The exhibition, which was held in the Assembly Room of the King's Head inn, charged admission of 1s for adults and 6d for children aged under eight, with an extra 6d required for entry into the 'separate room'. Originally advertised to run for a fortnight, the exhibition proved so popular that it was extended for an additional week – with a portrait of Queen Adelaide and the figure of Earl Grey, then Prime Minister, adding to the exhibits. It was three years after her last touring exhibition in Cirencester ended that Madame Tussaud established her first permanent exhibition in Baker Street, London.

DID YOU KNOW?

On 7 August 1944 Captain (later Major) Glenn Miller and the band of the American Expeditionary Force (AEF) played two concerts for staff and patients of military hospitals at Cirencester Park. After landing in a Dakota aircraft at RAF South Cerney airfield, he stayed overnight at The Shrubbery in Victoria Road. Just over three months later, the aircraft in which he was flying to Paris disappeared in bad weather over the English Channel.

Historic Outdoor Swimming Pool

Among the other unique treasures of the town's leisure facilities is the public outdoor swimming pool, recognised as one of the UK's oldest still in use. Opened in 1869 by the Cirencester Baths Company Limited, the baths were first considered ten years earlier but local millers objected to water being extracted from their millponds. Eventually, a site bordering the Gumstool Brook and the armoury-yard on Earl Bathurst's meadow was chosen because of its relatively low altitude. Around 100,000 gallons of water was supplied for the pool from an adjacent well, initially pumped in by horse power but, later, steam-driven. The water remained unheated until improvements were made in

1931. Among the early resolutions taken in 1870 were provision of ladies-only swimming sessions during one day per week, and a plan to adopt the practice, prevalent 'at most private baths in England and on the French coast', for male bathers to wear drawers. The importance of providing the facilities for the public good, rather than shareholders' profits, was also acknowledged.

Given that few people could swim at that time, events such as aquatic fêtes were often held as part of annual swimming races both to inspire and entertain local communities. At Cirencester, in 1874, one such event promised to showcase 'the most advanced style of modern high-class swimming'. Topping the bill was Fred Beckwith (1821–98), a self-styled 'Professor' and swimming instructor at Lambeth Baths and former swimming champion of England, along with two of his children, whose abilities he also strongly promoted. Such significant interest was anticipated that a temporary grandstand for 250 distinguished guests was built by the deep end. Beckwith's performance included undressing while swimming fully clothed, swimming with hands and feet tied together and, then, with one (or both) legs raised out of the water. As one of its early proponents, he also demonstrated sidestroke, along with 'waltzing' – a technique used to propel the body forward on the stomach, moving, alternately, right, then left. His thirteen-year-old daughter Agnes, nicknamed 'The

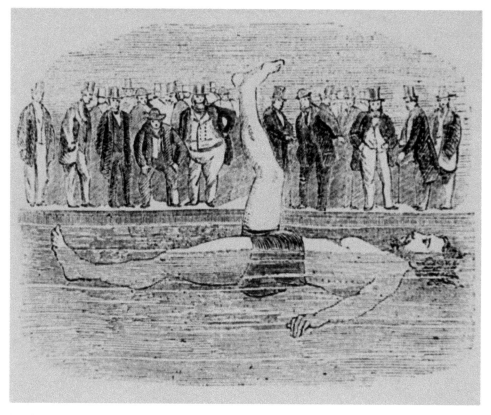

'Professor' Beckwith (from *Illustrated Sporting News*, 24 May 1862).

Mermaid' and promoted as 'the Queen of the lady swimmers of England', performed ornamental and floating displays, including the feat of passing through a hoop at each stroke, while William, his sixteen-year-old son, hailed as 'champion of the Serpentine' and considered the third best swimmer in England, demonstrated life-saving skills on his father who imitated a drowning man.

The events were interspersed with swimming and diving matches, one of which, the 440-yard handicap race, provided an opportunity for local swimmers to compete with some of the best in the country. While William boasted to 'give any man in the counties of Gloucester and Wilts 80 yards in a quarter of a mile', he still ended up victorious: after delaying his start to allow two contestants to take an early lead, he finally won the race by 10 yards.

Another event, in 1912, saw the ornamental swimming champion of the world, Florence Tilton of Gloucester, give an exhibition which included sewing, drinking a bottle of milk, and eating a banana under water. Much to the crowd's pleasure, she, then, wrote 'Success to the Cirencester S.C.' on a piece of the slate resting at the bottom of the pool. Appropriately, more than a century later, the town has delivered an excellent track record of success. In 2021, for example, three Cirencester swimmers came in the UK's top ten as part of the Level X series of time trials, which involved a total of 16,200 swimmers across the country. Thanks to the dedication of volunteers, the outdoor pool continues to welcome swimmers of all abilities during the summer season. No doubt, even 'Professor' Beckwith would have been impressed.

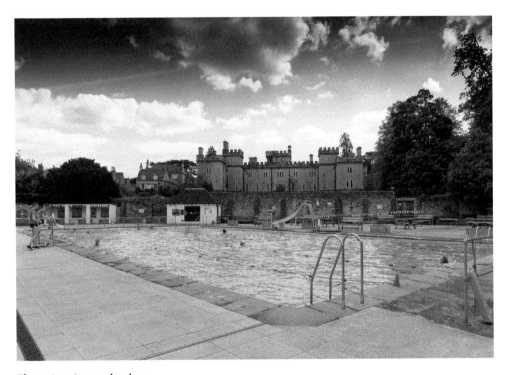

The swimming pool today.

A Remarkable Cricket Club

Even traditional sports, such as cricket, reveal some unique dimensions when viewed through a Cirencester lens. It would be difficult to find another cricket ground, for example, which harbours a Victorian fireplace within the shower area of its recently refurbished changing room facilities – something, which, in Cirencester's case, arose following the cricket club inheriting the former accommodation (now subject to conservation area regulations) of the local archery club. Other remarkable facts about the club include its organisation, in 1853, of a three-day match between a Cirencester XXII and the All England XI. This seems even more remarkable when one considers that the club was only founded in 1842, albeit cricket being played at 'Earl Bathurst's Park' from around 1829. Nevertheless, in those days the team sometimes struggled to recruit sufficient players. In 1834, for example, after being comprehensively beaten by Purton, a return match was eagerly anticipated. However, a medley game resulted after Cirencester could muster only eight members.

While the historic 1853 match ended in a draw, there was some local disquiet when the *Bristol Mirror* reported erroneously, 'The second innings was so much in favour of All England that the Cirencestrians yielded the palm without prolonging the contest'. Although repeat matches in 1855 and 1856 showed England's clear superiority – despite

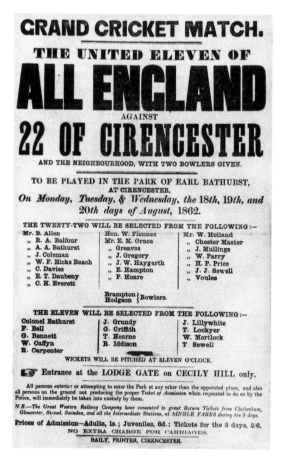

Poster advertising the 1862 cricket match.

Cirencester fielding two long-stops (in addition to the wicket-keeper) to cope with England's fastest bowler – Cirencester proved victorious in subsequent encounters in 1862 and 1864. Thereafter, its reputation grew as a leading centre for cricket in Gloucestershire and, in 1877, memorably hosted a match between Gloucestershire and XXII Colts, the former's side including the three famous Grace brothers (W. G., E. M. and G. F.). On that occasion, while W. G. took an astonishing ten wickets off 144 balls, he took an even more remarkable fifteen wickets (8 for 81, and 7 for 35) when playing on the same ground against Surrey in 1879.

An analysis of the club's history off the pitch also reveals some surprises. During the latter half of the nineteenth century the club showed considerable creative and enterprising spirit: after setting up a successful amateur dramatic company it raised funds for both itself, and, also, occasionally, Stroud Cricket Club. Their November 1900 production of the farce *The Strange Adventures of Miss Brown*, for instance, was a sell-out at the Corn Hall. Generating much 'rollicking fun', the performance cast the then club captain Sydney Boulton as Captain Courtenay who underwent many 'strange adventures' dressed in feminine attire as Miss Brown, while the butler was played by South African-born Cyril Sewell (1874–1951), an accomplished batsman who played for Gloucestershire and the Marylebone Cricket Club (MCC) and took over the captaincy from Boulton in 1905. Receipts from the annual theatrical and musical performances remained an important part of the club's income until the 1930s.

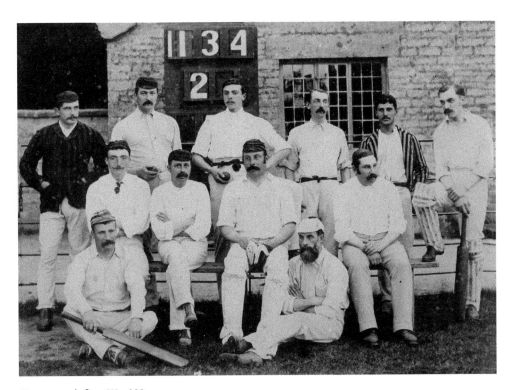

Cirencester's first XI, 1888.

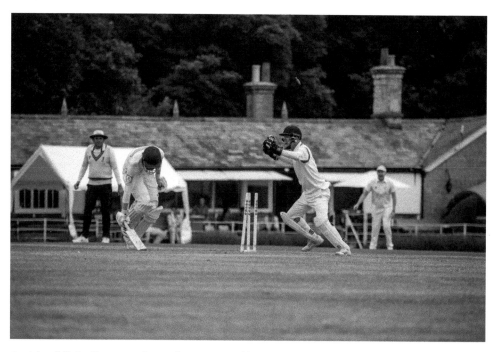

A wicket falls in Cirencester's match against Rockhampton, 24 July 2021.

Today, the club concentrates more on its performances on the pitch, and its motto *prorsum semper* (meaning 'ever forward') was perhaps particularly demonstrated during the Second World War when it became one of the few clubs in Gloucestershire that decided to continue playing for as long as possible, despite the number of players absent on military duty. This was much to the amusement of US soldiers, then stationed at the nearby American hospital, who recalled their disbelief when they saw the townsfolk playing cricket while the rest of the world was preoccupied with the current state of emergency. At that time, while the war prevented the outfield from being cut, players were simply instructed to hit the ball harder.

DID YOU KNOW?

Walter (Wally) Hammond (1903–65) attended Cirencester Grammar School where, famously, he hit a remarkable 365 not out in a boarders' match. Summed up in *Wisden* as 'one of the cricketing immortals', Hammond was recommended by the headmaster to play for Gloucestershire, and made his debut for the county at the Cheltenham Festival shortly after his seventeenth birthday. Another Cirencester legend was Charles Barnett (1910–93), a stylish batsman of the 1930s who played for Gloucestershire and England and, later, owned a fish and game shop at the corner of West Market Place.

7. Curiosities

Exploring Cirencester today sometimes throws up the unexpected or unusual. Among the curiosities that lie hidden beneath the surface are tunnels, identified by the Bristol and Gloucestershire Archaeological Society (BGAS) during the 1980s, when the new hospital was being built on the site of the Roman quarry at the Querns. At other times, bizarre features may be clearly visible, but not easily understood. For many passers-by, for example, the two holes cut in the Bathurst Estate wall approximately 50 metres before Tetbury Road meets Park Lane may simply be viewed as 'two holes in a wall' rather than a rare example of a loopholed wall. The holes were created during the Second World War for defensive purposes and would have been used by infantrymen had an invasion occurred.

The loopholed wall on Tetbury Road.

A Local Cult

Among the remarkable archaeological finds housed in the Corinium Museum are sculptures of triple mother goddesses, indicating the existence of a once popular local cult. Discovered at various sites, including Ashcroft, Watermoor Road and Daglingworth, the Deae Matres appear to have been worshipped both in temples and villas as symbols of fertility, prosperity, healing, and maternity. Sometimes, as illustrated in the Ashcroft sculpture, they were depicted carrying baskets of food, such as fruit and loaves of bread. Whether they represented three different aspects of a single goddess or three separate entities is not known, but it is known that similar cults existed across parts of northern Europe during the Romano-Celtic period. These goddesses possibly derived from the Celtic world and became tolerated and incorporated into Roman life in the same way that the Celtic goddess of healing, Sulis, at Bath, later became paired with Minerva, the Roman goddess of wisdom, to become integrated as Sulis Minerva, the goddess of healing and wisdom. Indeed, this theory is reinforced through evidence from inscriptions indicating that the Cirencester goddesses may have been known locally as *Suleviae*, the Latin name given to a triad of mother-goddesses, which also links them with Sulis.

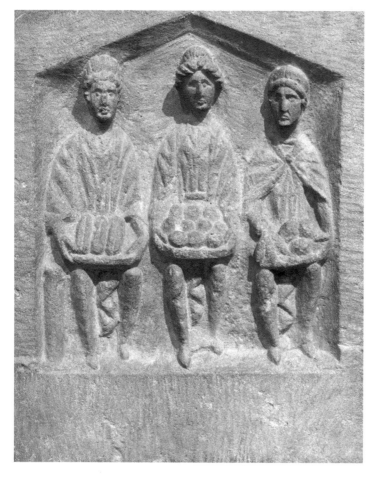

Ashcroft Relief of the Mother Goddesses discovered in 1899.

DID YOU KNOW?

Details of the history of Cirencester's obelisk remain a complete mystery. Thought to have possibly marked the boundary of the Bathurst Estate or formed part of the park's architectural follies, the 50-foot-high structure has never been properly documented, or even accurately dated. While possibly constructed in the 1740s, it remains absent on maps until 1807, and, given that it is uninscribed, there are no clues about its original function.

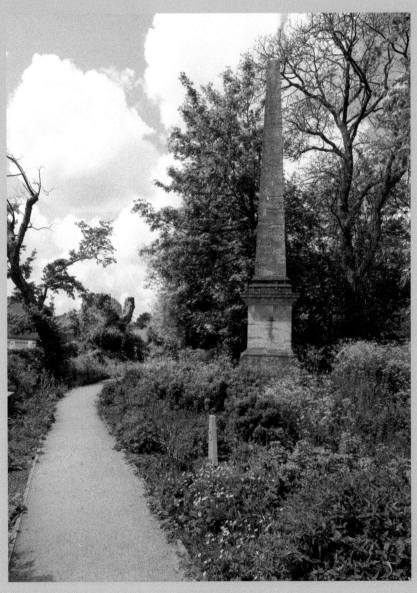

The obelisk whose origin remains a mystery.

Grismond's Tower

Located in the grounds (not publicly accessible) of Cirencester Park mansion lies one of the town's least well-known, yet most intriguing, places, Grismond's Tower (see also p.7). Unusually, it contains an ice-house within its mound, another example of an ice-house also being found in the Abbey Grounds on the northern side of the lake. Grismond's Tower ice-house was built *c.* 1780 and remained in operation until the mid-1930s when, in the age before refrigerators, it was used to store up to around 16 tons of ice, cut from the nearby lake during winter months. Its central ice-well, ovoid in form and constructed with bricks laid in Flemish bond, remains intact today, measuring approximately 3 metres wide and 6 metres deep. Yet, possibly, a more remarkable story may be told about this site based on its earliest known documented reference, recorded by the antiquarian and chronicler William of Worcester (1415–*c.* 1485). Referring to Cirencester, he commented that Grismond's Tower was the place where King Arthur was crowned. While most historians have rejected this claim as part of the fanciful fabrications inspired by Geoffrey of Monmouth, Welbore St Clair Baddeley even commenting, 'Had this story a less questionable origin, Cirencester, like Edinburgh, might have had an Arthur's Seat upon this very mound', it is true that ancient barrows were sometimes used as places for coronations in the early medieval period. Whatever the truth, it is known that the site undoubtedly formed part of a later chapter of the town's history when the mound, then under the ownership of Henry Poole of Sapperton and known as Poole's Mount, was used as a gun emplacement by Parliamentary forces during the Civil War.

The entrance to the ice-house at Grismond's Tower (private property).

Hidden Colour

While Cirencester is famed for its mellow Cotswold stone buildings, as a medieval town many of its buildings were often brightly painted. The interior of the parish church, for example, once included colourful murals, which were scraped off or whitewashed over during the Reformation. One surviving detail on the north wall of St Catherine's Chapel, however, was revealed in 1865 as part of the church's restoration. This shows St Christopher against a design of pomegranates on a red background. Another mural, one in the Trinity Chapel showing the gruesome martyrdom of St Erasmus lying serenely on a bed of nails while his intestines were extracted by a winch, only survives as a print after Georgina, wife of the 3rd Earl Bathurst, insisted on its destruction. Ironically, today her memorial lies adjacent to a copy of the print. Polychromatic decoration was not just confined to walls; it was also used in sculptures. One of the buildings which temporarily revealed its colourful heritage during restoration work in April 2010 was the Weavers' Hall, or St Thomas's Hospital, in Thomas Street, celebrated as the town's oldest secular building still in use following its endowment by Sir William Nottingham in 1483 'for the use benefyt and mayntennance of fower poore men'. Today, its rather austere façade belies the fact that a rare polychromatic sculpture, thought to depict St Michael overcoming Satan, was discovered in the wall above the entrance by the Cirencester-born sculptor Rory Young during the repair work.

Above left: The surviving mural in St Catherine's Chapel.

Above right: The sculpture temporarily revealed in the Weavers' Hall in 2010.

Cirencester Beasts

Whether it is the phoenix, included in the town's crest and used as a symbol of Cirencester since at least the seventeenth century, the so-called 'Tom and Jerry' carving of a cat and mouse on the roof brace in the Lady Chapel of the parish church, or sparrows, said to have been used to burn the town down (see p.15), Cirencester has often been associated with mythical and other beasts drawn from nature. Perhaps the greatest diversity of these is found at the front of the South Porch (also known as the Town Hall) of the parish church, widely recognised as 'the most splendid of all English church porches'. Here, a series of stone carvings intrigue passers-by who may not be aware of their symbolic significance. Why does an alert weasel sit on one side next to a buffoon, seemingly drinking from (or blowing into) a leather bottle, while, on the other, a crouching fawn turns (or climbs) over an obstruction? According to research carried out by Malcolm James, project surveyor, in 2011, as part of work to replace and conserve the figures, the answer lies in the bestiary, the medieval book of beasts, and the Whitsun Ale festivities. It is thought that the buffoon represents a drunkard (perhaps a reformed one if, indeed, he is blowing into the bottle) symbolising the sinner who faces redemption and judgement, while the fawn signifies someone 'being hastened to Christ', who, should they encounter places of sin, simply leaps over them and, additionally, helps others less fortunate than themselves to achieve goodness. On the other hand, the weasel combines qualities of cunning, caring for its young, and the courage to defeat large foes – 'the perfect symbol of a Christian who, no matter how weak in himself, can still triumph over Satan'. Positive elements of this allegorical interpretation deriving from medieval bestiary can even be seen today in J. K. Rowling's *Harry Potter* books where Ron Weasley is depicted as Harry's devoted follower and friend. One more

Above left: Phoenix shield representing Cirencester town in the parish church.

Above right: The 'Tom and Jerry' carving in the Lady Chapel.

Weasel, carved by Wieslaw Szot to a design by Rory Young.

The fawn, carved by Wieslaw Szot to a design by Rory Young.

The buffoon.

dimension to possible interpretations of this set of carvings was that they acted as a challenge to onlookers – to consider whether they identified more with the self-sacrifice of fawns than the deceitfulness of weasels. Whatever is the correct interpretation, these carvings still provoke considerable interest – inspired by the age-old conflict between Good and Evil.

Perhaps the most remarkable of all 'beast stories' concerns Kenley Lass, a pigeon who received the Dickin Medal, the animals' Victoria Cross, in 1945 from the People's Dispensary for Sick Animals. Then owned by Don Cole, the landlord at the Bull Inn (formerly located at 72 Dyer Street), the dark-chequered hen was recruited by the National Pigeon Service in 1940 and given the code NURP.36.JH.190. In October 1940 she became the first pigeon to successfully carry secret messages from an agent (codenamed Philippe) in enemy-occupied France. After being dropped with her agent by parachute and then carried in his haversack – most likely in an old sock with cut-out holes – Kenley Lass completed the 300-mile return flight within seven hours, paving the way for more pigeons to be used for secret intelligence work.

Follies

Among Cirencester Park's unique treasures are various follies dating from the eighteenth century. Perhaps the most mysterious is Alfred's Hall, standing in a secluded clearing in Oakley Wood. Originally called King Arthur's Castle and also referred to

as the Woodhouse, the mock-Gothic ruin, thought to be the earliest in England, was renamed Alfred's Hall possibly based on the (erroneous) belief that King Alfred had stayed in Oakley Wood prior to the Battle of Edington in 878. Although dated 1085, it was designed by Earl Bathurst with Alexander Pope in 1721. The original structure was rather shoddily built and collapsed in 1727, not long after another of Bathurst's literary friends, Jonathan Swift, lodged there. Described by Bathurst then as a 'pretty little plain work in the Brobdingnag style', it was rebuilt six years later, incorporating parts of the demolished manor house at nearby Sapperton and featuring a bowling-green, lawns and walks. By 1736 the sham ruin, complete with a fake inscription in Saxon characters, had fooled a respected Oxford antiquary and, at times, tongue-in-cheek remarks claimed its 'ancient' fireplace was the place where Alfred accidentally burnt the cakes. Even by 1874 a textbook for cycling enthusiasts noted Alfred's Hall as one of the objects of interest along its recommended route from Bath to Nottingham, commenting that this was 'where King Alfred signed the treaty with Guthrum, the Dane'. A favoured location for outings, fêtes and picnics, particularly during the late Victorian period, the folly received visits from various organisations, including the Vale of the White Horse (VWH) Hunt, the Primrose League, and the Working Men's Club, the latter, in 1871, enjoying games of quoits and cricket, dancing, and tea for 100 people in the great hall. Sadly, today it has fallen into a dilapidated state again and is rarely visited because of its remote location.

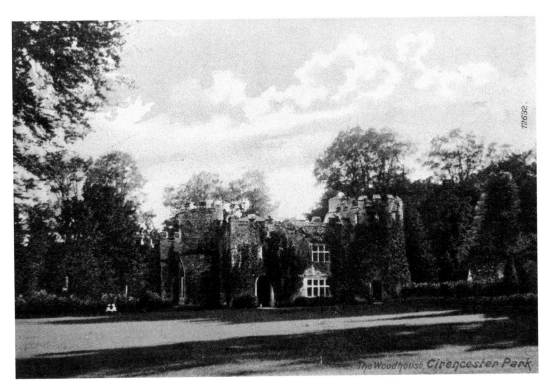

Alfred's Hall, as depicted in an Edwardian postcard.

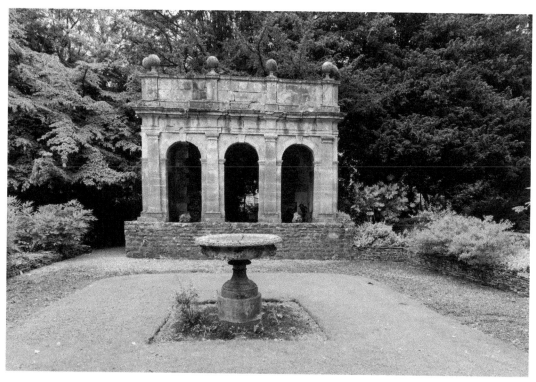

The Horse Temple, now Temple Garden (private property).

While other follies, including the Hexagon (built in 1736) and Pope's Seat, a 'Sylvan Bower', known to have been a favourite haunt of the poet, are frequently visited, more hidden away today is the Horse Temple (not publicly accessible), now located roughly halfway between Cirencester Mansion and Grismond's Tower. Originally located around 600 metres south of the Hexagon, the temple was moved in the early nineteenth century to the mansion's private garden, where it is now called Temple Garden. At one time it contained a statue of Agamemnon, which was popularly known as 'Mad Tom'.

The Thirteenth Bell

The peal in St John's Church has, rightly, been a source of pride throughout the town's history, extending back at least to 1499 when Agnes Benett, a 'widowe of Cisciter' made various bequests regarding the bells, two of which ('the Trinite belle and Jesus belle') were, later, sounded at her funeral. First cast in 1722, the current peal of twelve is probably the oldest in the country, the earlier established one at St Bride's, London, having been destroyed during the Second World War. At one time the ninth bell also served as a fire-bell, although this was considered unsatisfactory given that rough handling might result from those called upon to use it in an emergency who would be unfamiliar with the way in which the bells were hung. The solution came in 1895 when the Cirencester Society in London donated a thirteenth bell. Cast in C, this bell provided a light octave and was used by the police until the Second World War to summon the fire brigade. A

The thirteen bells today.

rededication service, held at the church on 11 May, provided the opportunity for the bell to be rung for a quarter of an hour beforehand to enable the townsfolk to distinguish its tone. Then, later in the afternoon, some members of the Gloucester and Bristol Diocesan Association of Change Ringers attempted a long and difficult peal of Stedman Cinques. Unfortunately, although newly installed ropes had been correctly weighted a recent spell of hot weather caused them to become too springy, leading to an unsuccessful rendition. While the thirteenth bell was unlucky on this occasion, it served its purpose, six months later, after being rung following the discovery of smoke from an upstairs room in Sheep Street, where, at that time, four children lay in bed as the sole occupants.

DID YOU KNOW?

Various curious bell-ringing customs and regulations have existed over the ages. The tenth bell was once rung to announce curfew starting at 8 p.m. from 8 November to 25 March, except weekends and Mondays. The ninth bell, known as the Shriving Bell (more popularly Pancake Bell), is still rung at midday on Shrove Tuesday. In 1656 the funeral bell was tolled 'for six hours and not lesse' and charged at 12*d* per hour, while, five years later, the charge of 3*s* was instituted for 'any stranger ... to hear the bells ring'.

Three Wise Monkeys

Anyone who climbs to the top of the parish church tower cannot fail to be impressed with the renovation of its 20-foot-high pinnacles. Completed in 2007, the restoration work also included replacing three worn gargoyles. Because the commissioned work was required urgently in view of the potential danger of falling masonry, the stonemasons concerned, Jonny Anderson and Tristram Phillips, were pretty much given complete freedom to suggest their own design. Inspired by the pictorial maxim of the three wise monkeys, 'see no evil, hear no evil, speak no evil', the new gargoyles provide much pleasure and curiosity. Most visible of the three is a punk rocker, carved by Tristram. Facing the town with his hand covering his mouth, this 'monkey' symbolises the town's 'street' community speaking no evil. Harder to spot and appreciate up front are the other two. Although now officially described as representing a businessman and a farmer, these gargoyles were, in fact, originally based on famous people. The 'monkey' that faces in the direction of Fairford, hearing no evil, with hands over his ears, was conceived by Tristram as George Bush, while the one facing Highgrove, with hands over his eyes, was originally intended by Jonny to be Prince Charles. Whichever way these figures are interpreted, the new gargoyles bring a unique dimension to one of the town's most treasured buildings, and accord well with the church's tradition of occasionally interjecting elements of gentle humour.

The farmer who 'sees no evil', carved by Jonny Anderson.

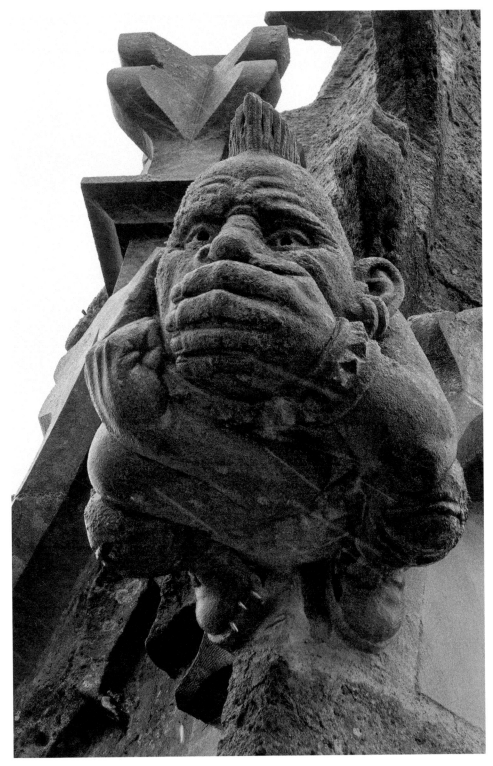

The punk rocker who 'speaks no evil', carved by Tristram Phillips.

Bibliography

Baddeley, Welbore St Clair, *A History of Cirencester* (Cirencester Newspaper Company: Cirencester, 1924).

Beecham, Kennet J., *History of Cirencester and the Roman City Corinium* (G. H. Harmer: Cirencester, 1887).

Grace, Peter, *Cirencester at War* (Amberley Publishing: Stroud, 2017).

Griffiths, Peter, *Cirencester Pubs Through Time* (Amberley Publishing: Stroud, 2013).

Heaven, Robert, *Lost Cirencester* (Amberley Publishing: Stroud, 2021).

Lewis-Jones, June R., *Cirencester: A History and Celebration* (Francis Frith Collection for Ottakers: Salisbury, 2004).

OldCiren [collection includes the *Wilts and Gloucestershire Standard* newspaper's archive of photographs taken between 1965 and 1995, and a link to a Facebook social media group for people who were brought up in (or who have close associations with) Cirencester]. *https://www.oldciren.com/*.

Rudder, Samuel, *The History of the Antient Town of Cirencester, in two parts* (S. Rudder: Cirencester, 1780, 2nd ed.).

Tomkins, Richard, *Street Names of Cirencester* (Red Brick Publishing: Swindon, 1987).

Viner, David and Linda, *Cirencester a Century Ago: The Bingham Legacy* (Sutton Publishing: Stroud, 2004).

Viner, David and Linda, *Cirencester From Old Photographs: The Bingham Legacy* (Amberley Publishing: Stroud, 2016).

Viner, David and Linda, *Cirencester Through Time* (Amberley Publishing: Stroud, 2009).

Welsford, Jean, [rev.ed. Welsford, Alan], *Cirencester: A History and Guide* (Amberley Publishing: Stroud, 2010)

Acknowledgements

I would like to acknowledge the considerable kindness of numerous individuals who have assisted in the production of this book, including through reviewing draft text and granting permission to take photographs. Particular thanks are due to Danny Abbot, Beth Alden, Lord and Lady Bathurst, Isabel Branch, Danielle Brown, Phil Carter, Barbara Chamberlain, Lucy Cordrey, Garrett Gloyn, James Harris, John Harris, Robert Heaven, Malcolm James, Trish Jennings, John Lawrence, Hannah Lowery, Richard McKim, Nick Price, Sian Prosser, Helen Timlin, David Viner, Linda Viner, Martin Watts, Sue Webb, Jill Waller, Jo Welch, Valerie Wheeler, and Rory Young. Likewise, I am grateful for the support and permissions received from the following institutions: Bingham Library Trust; British Astronomical Society Archives; Cirencester Religious Society of Friends; Corinium Museum; Gloucestershire Archives; Gloucestershire Library Services, Gloucestershire Police Archives, and Royal Astronomical Society Archives. I would also like to thank the following who kindly supplied the following images: Jonny Anderson for p.92; John Batten for p.33; Bingham Library Trust for p.14 and p.15.; the Brunel Institute – a collaboration of the ss Great Britain Trust and the University of Bristol for p.56; Nick Catford for p.57 (bottom); Cotswold Archaeology for p.64; Gloucestershire Police Archives for p.42, p.43, p.47, and p.49 (top); Robert Heaven for p.17 (top and bottom), p.19, p.32, and p.67; Library of Congress for p.31, and p.74 (top left); Richard McKim for p.27 and p.29 (left); Wellcome Collection for p.46, p.53, p.60, p.66, and p.74 (top right); Rory Young for p.22, and p.85 (right). Finally, my heartfelt thanks to my family, Meg, Rachel and Catrin, for their patience, understanding and support.

About the Author

David Elder read Modern Languages at Bristol University and then, after training as an Information Specialist, enjoyed a career in central government. Now retired, he is the author of several books on Cheltenham, Gloucester, Tewkesbury, Gloucestershire and the Cotswolds, as well as some biographies and plays. As an award-winning photographer he often illustrates his books. You can find out more about David's writing and photography from his website, davidelder.net.